Temporary Tattoos

for Guys

Temporary
Tattoos
for Guys

Russ Thorne & Andrew Trull

WITH 100 TEMPORARY TATTOOS
designed by real tattoo artists

CHARTWELL
BOOKS, INC.

This edition published in 2010 by
Chartwell Books, Inc.
A division of Book Sales, Inc.
276 Fifth Avenue Suite 206
New York, New York 10001
USA

ISBN-10: 0-7858-2657-2
ISBN-13: 978-0-7858-2657-6
QTT.TBOY

A Quintet book
Copyright © Quintet Publishing Limited
All rights reserved.

This book was conceived, designed, and produced by
Quintet Publishing Limited
The Old Brewery
6 Blundell Street
London N7 9BH
United Kingdom

Designer: Jane Laurie
Illustrator: Andrew Trull
with additional illustrations by Betsy Badwater and Jane Laurie
Art Director: Michael Charles
Managing Editor: Donna Gregory
Publisher: James Tavendale

Printed in China

10 9 8 7 6 5 4 3 2 1

ABOUT THE TEMPORARY TATTOOS:

Ingredients: Polypropylene, Styrene/butadiene Copolymer, Polyvinyl
Alcohol, CI 77491 (Iron Oxides), CI 45410 (Red 27), CI 47005 (Yellow 10),
Acid Blue 9 (Blue 4)
Manufactured in China
Batch no: QDBCSR96297

CONTENTS

HOW TO USE THIS BOOK

Each of the top ten design categories for tattoos for young men has a dedicated chapter, and has ten original transfer tattoos designed by real tattoo artists at the back of the book.

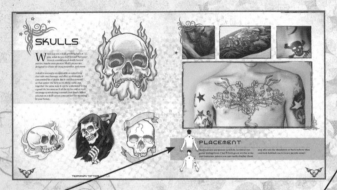

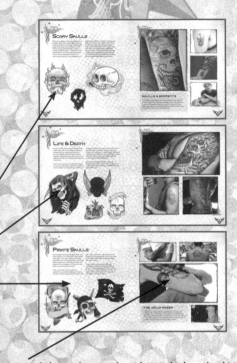

Each chapter has suggested tattoo placement ideas for the designs discussed.

Every design shown on the pages here is available as a tattoo transfer in the final 5 pages of this book.

Real photos show you how designs look on the skin.

The final 5 pages in this book are tear-out sheets of temporary tattoo transfers. There are more than a hundred designs to choose from! Simply follow the instructions opposite to get started.

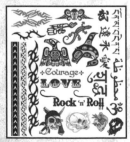
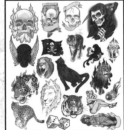
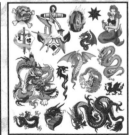
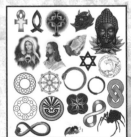
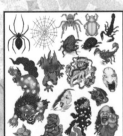

HOW TO APPLY THE TEMPORARY TATTOOS

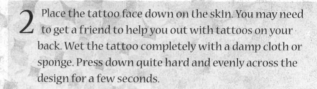

1 First, choose your tattoo design from the 5 tear-out pages at the back of this book, and then select the position on your body that you'd like the tattoo to be placed. **Do not use on broken or irritated skin, or on the face or neck.** Clean and dry the skin around the chosen area completely. Cut out the design of your choice and remove the transparent film.

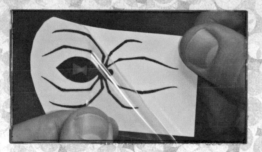

2 Place the tattoo face down on the skin. You may need to get a friend to help you out with tattoos on your back. Wet the tattoo completely with a damp cloth or sponge. Press down quite hard and evenly across the design for a few seconds.

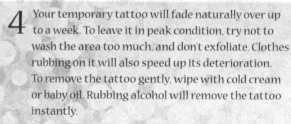

3 Peel the corner of the tattoo gently to check if it has transferred. If it hasn't completely transferred, wet again and press down. Your tattoo can last for several days if transferred carefully and looked after.

4 Your temporary tattoo will fade naturally over up to a week. To leave it in peak condition, try not to wash the area too much, and don't exfoliate. Clothes rubbing on it will also speed up its deterioration. To remove the tattoo gently, wipe with cold cream or baby oil. Rubbing alcohol will remove the tattoo instantly.

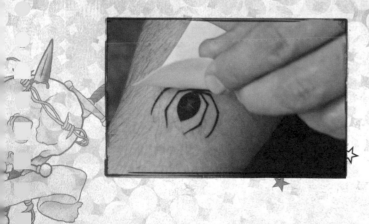

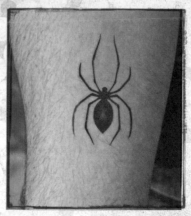

INTRODUCTION

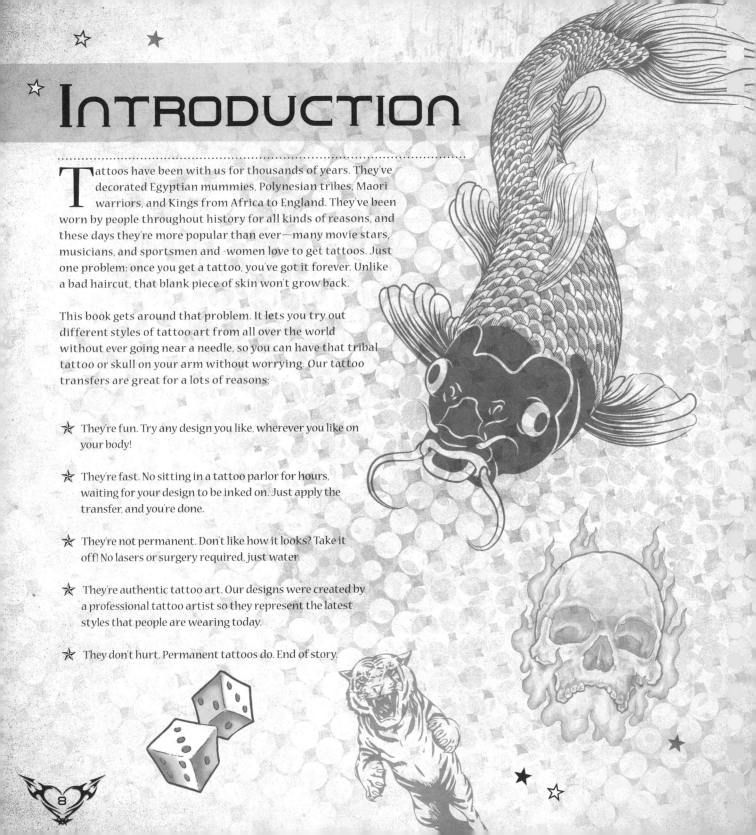

Tattoos have been with us for thousands of years. They've decorated Egyptian mummies, Polynesian tribes, Maori warriors, and Kings from Africa to England. They've been worn by people throughout history for all kinds of reasons, and these days they're more popular than ever—many movie stars, musicians, and sportsmen and -women love to get tattoos. Just one problem: once you get a tattoo, you've got it forever. Unlike a bad haircut, that blank piece of skin won't grow back.

This book gets around that problem. It lets you try out different styles of tattoo art from all over the world without ever going near a needle, so you can have that tribal tattoo or skull on your arm without worrying. Our tattoo transfers are great for a lots of reasons:

☆ They're fun. Try any design you like, wherever you like on your body!

☆ They're fast. No sitting in a tattoo parlor for hours, waiting for your design to be inked on. Just apply the transfer, and you're done.

☆ They're not permanent. Don't like how it looks? Take it off! No lasers or surgery required, just water.

☆ They're authentic tattoo art. Our designs were created by a professional tattoo artist so they represent the latest styles that people are wearing today.

☆ They don't hurt. Permanent tattoos do. End of story.

OTHER TEMPORARY TATTOOS

Henna

Also known as Mehndi, henna tattoos use a paste made from the leaves of the henna plant to temporarily dye the skin. Decorating with henna is thought to have started in India, and is an important part of Hindu and Muslim culture.

Airbrush Tattoos

These are painted onto the skin using a stencil and an airbrush—they look identical to permanent tattoos, so the technique is often used in movies, fashion, and music videos.

Pen

Because ballpoint pen ink is safe, and the designs can be so complex, tattoos drawn in pen can look almost like the real thing, and were popular in the 1990s. You can get longer-lasting, specially designed tattoo pens now too.

NOT JUST PRETTY IN PICTURES

People can wear tattoos for fun and decoration, but for some people their tattoo designs carry a lot of personal meaning. This book also tells you all about the history and symbolism behind the designs, so you'll be able to pick tattoos that say something about you, protect you, or both. A dragon tattoo can tell people you're strong, and protect you from evil spirits at the same time, for example.

We've chosen ten of the most popular tattoo styles for this book, and included some of the most requested designs, so this book is an ideal introduction to the rich and varied world of tattoo art. Take a look, and enjoy!

A (VERY) SHORT HISTORY OF TATTOOS

No-one knows exactly when the first tattoos appeared, but we know that the practice of tattooing has been around for many thousands of years. It also seems to have appeared independently in different cultures around the world who had no contact with each other.

One of the earliest people to wear a tattoo discovered so far is a Bronze Age man who was alive in around 3300 BCE. Nicknamed "Otzi" after the area of the Alps he was found in, his skin was preserved by ice, and shows dark blue tattoos of parallel lines, and a cross. Warriors from Siberia's Iron Age (600–200 BCE) have also been found covered with elaborate animal tattoos, and there is evidence of tattoos amongst Inuit tribes, Native Americans, ancient European tribes, and South American cultures. Tattooing in China, and Japan may be even older—some evidence suggests it was practised as long ago as 5000–10,000 BCE—and there are theories that tattoo art existed in Paleolithic Europe (38,000–10,000 BCE). Cavemen probably didn't have "I ♥ mammoth" tattoos, but tattooing is definitely an ancient practice that's existed in one form or another for almost as long as we have.

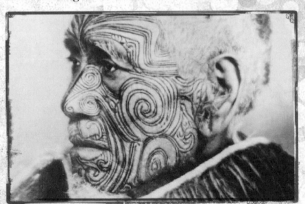
Vintage portrait of a tattooed Maori man.

TATTOO ART GOES WEST

"Modern" tattoo art owes a lot to the sailors who returned from their travels with different designs inked onto their skin (there were no souvenir shops in those days, after all). A good example is the tribal style of the South Pacific, as seen by eighteenth-century explorers like Captain James Cook, and his crew. They were some of the first Europeans to get "tribal" tattoos, setting up tattoo shops in harbors when they returned home, and sharing the art with their customers. Over time the traditional styles evolved to form the modern tribal style we know today.

Meanwhile, sailors were discovering the Chinese and Japanese styles, and other types of art from all over the world, and bringing them home, contributing to the worldwide spread of tattoos and tattoo culture.

OUCH!

The first tattoos were tapped in with sharpened pieces of bone or wood dipped in ink or carbon; getting one was often a sign of faith or symbolic of becoming a man, because it was bloody, painful, and showed the wearer had strong beliefs or was tough enough to take it. Over time other methods—including the use of needles—arose, until the first tattoo machines appeared towards the end of the nineteenth century. Luckily, the worst a temporary tattoo will do is clean your skin when you wash it off...

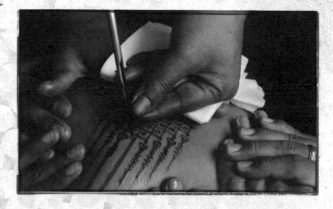

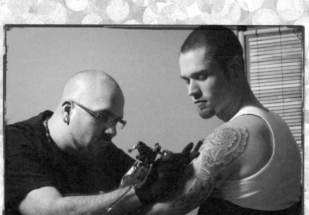

TATTOOS TODAY

These days tattoo art embraces every style under the sun, from elaborate traditional Japanese backpieces of tigers and dragons, to modern biomech art that fuses images of the natural world with weird mechanical imagery to create cyborg-like designs. You can even get black light tattoos which only show up under UV lights. Most things you can think of—and lots of things you can't—exist as a tattoo somewhere.

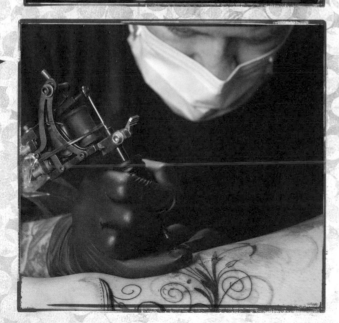

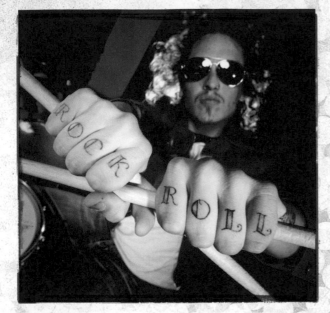

WHY WEAR A TATTOO?

People might have a tattoo for many different reasons.

⭐ To bring luck or protect from harm.

⭐ To look (or feel) stronger and tougher

⭐ As a memorial to a loved one.

⭐ To show their beliefs to the world.

⭐ Because it looks good!

In the end it's down to the individual, but it's always good to know what a tattoo means to you, whether it's temporary or permanent, because people always ask!

BAD ART

Tattoo art hasn't always been a positive thing that people use to express themselves. It's been used to brand people such as criminals, outcasts, slaves, and prisoners of war; tattoos were used by the Nazis in World War II to identify Jewish prisoners in concentration camps. Today tattoo art is much more widely accepted but there are still some images—like the Nazi swastika—that carry negative associations, so the majority of professional tattooists won't use them.

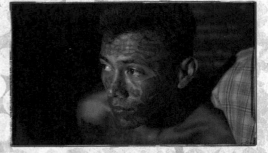

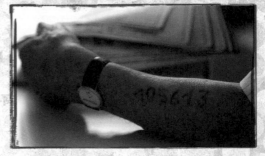

RIGHT, ABOVE: The tattoos on this man show that he belonged to a group called the Mara Salvatrucha, a highly dangerous criminal gang who operate in Los Angeles. RIGHT, BELOW: A Holocaust survivor shows his Auschwitz concentration camp number.

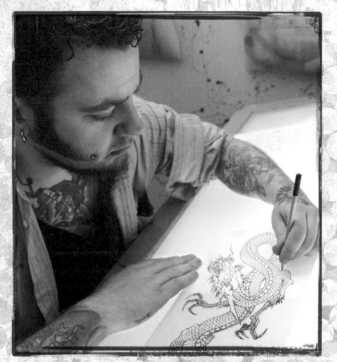

CHOOSING YOUR ART

Where do you start? This book will give you an introduction to some of the most popular styles and designs, so use it to get a feel for the kind of thing you like. Then start looking through tattoo magazines, websites, and reference books to explore some more. Check out the work of local tattoo artists, and see if you enjoy what they're doing—if you're trusting someone with your actual skin, you want to know you like their art, after all. You'll be looking at it forever.

Of course, there's nothing wrong with walking into a tattoo studio, picking some art from the wall, and getting it done. Lots of people do. But don't forget, anything can become a tattoo—from your favourite cartoon to the Mona Lisa—so it's worth taking your time, talking to artists you like, and having them come up with something unique that's customized for you. That way your tattoo will really say something about you, whatever artwork you choose.

THINKING ABOUT INKING?

Getting something inked permanently onto your skin needs plenty of thought beforehand. There are obvious issues like cost and potential health risks, but biggest of all is the fact that a tattoo is going to be with you for the rest of your life—so it's worth taking your time over. When you're 40, 60, or even 80 years old, will you still like that random picture of a kitten you grabbed from the internet and got inked on your foot when you were with your first girlfriend?

Our transfers are real tattoo art, the kind professional tattooists might use on their clients, which means you can use them to see if you'd be happy wearing a design forever. Put one on, and leave it for a few days: does it look good? Will you get sick of it? Where's the best place for it? You can also find out what the design you like means, and what it might say about you. A permanent tattoo is not for everyone: this book can play a small part in deciding whether or not it is for you. Either way, tattooing is a fascinating art form in its own right, and we hope you enjoy discovering more about it.

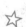

x

TRIBAL

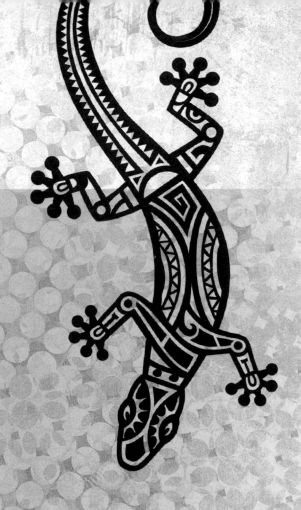

Tribal tattoos are probably the most widespread style of tattoo in the world today. They're also one of the oldest styles: members of tribes across the world, from Borneo to North America, have been tattooing themselves for hundreds—even thousands—of years. You got them as a rite of passage, or to show you were married—even to show how many enemy heads you'd cut off!

Modern tribal tattoos are inspired by these ancient styles, with lots of solid black, sweeping lines and sharp edges. Guys can for wear them for traditional reasons—to look tough, to show pride in their heritage and family background, or to show they've become an adult. But modern tribal tattoos don't need deep meaning—sometimes guys just pick them because they're bold, dramatic, and look great.

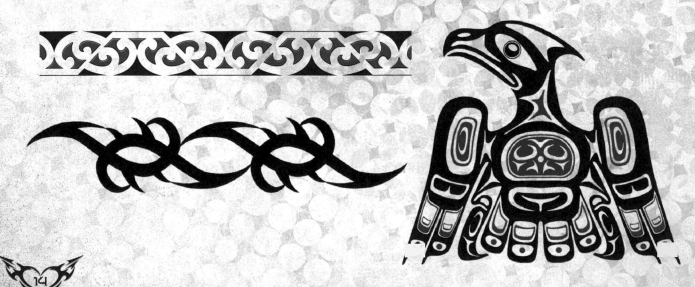

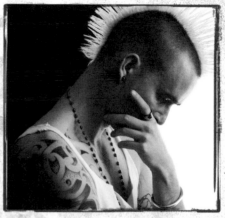

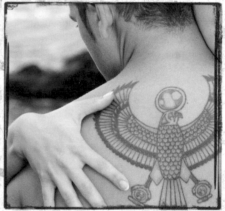

PLACEMENT

Tribal tattoos are big, bold, and designed to catch everyone's attention. They're usually worn on the upper arms, chest, and back so that they're easy to display, but traditionally men had them all over their bodies, so feel free to try them out wherever you like! Forearms, legs, and even hands can work as sites for your tribal tattoo.

Polynesian & Maori

Polynesia refers to a group of around 1000 islands—including Hawaii, Easter Island, and New Zealand—scattered over the Central and Southern Pacific ocean. The traditional forms of tattooing there were very intricate, sometimes covering the entire body, and are mentioned in the journals of explorers like Marco Polo and Captain Cook.

Polynesian tattoos use complicated geometric patterns. They were often worn by warriors, so guys might choose them to show they're tough, or that they've grown from a boy into a man.

The tattoos of the New Zealand Maori people are very distinctive. Called ta moko or moko, they're based on spiral patterns, and traditionally followed a lot of rules, depending on which tribe the wearer belonged to, and where they came from. The designs explain about a person's family, and what's happened to them in their lives, so people might choose them to show that family and their personal history is important to them. You might not want to put your moko on your face like the Maori did (and sometimes still do), but the designs still look good on other parts of the body.

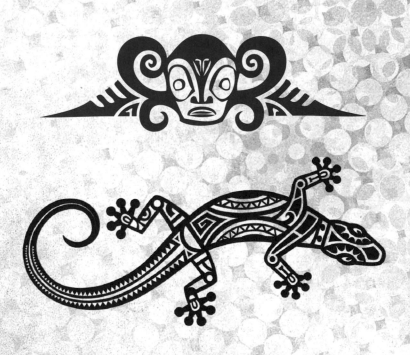

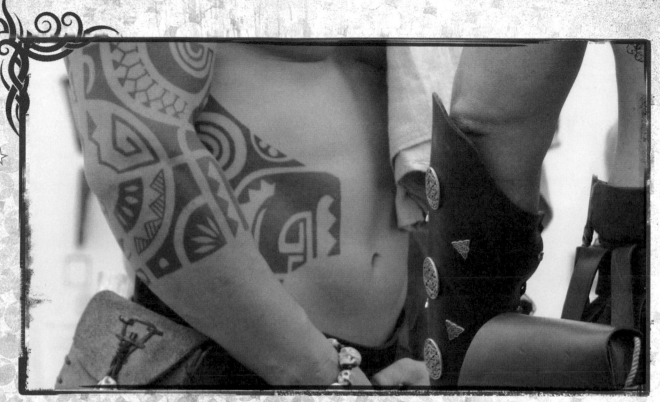

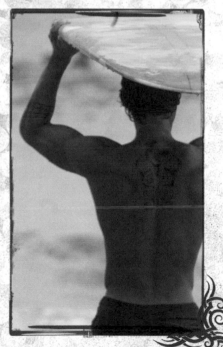

WEAR TO SCARE

Tribal tattoos can tell you a lot about the wearer's life, but they can also be used to intimidate people. Some warriors would have them on their arms to distract their enemies in battle, for example. Modern guys might have them to make themselves look and feel tougher, or even to scare their opponents when playing aggressive, competitive sports like boxing, hockey or football (they're not so good for chess).

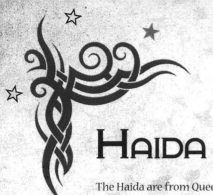

Haida

The Haida are from Queen Charlotte Island, on the North-West coast of North America. They have an incredibly distinctive style of tattooing, and are thought to be one of the few tribes to use color in their tattoo art. Haida tattoos use red, black, and white, and often feature totem animals or supernatural creatures like the Thunderbird, a mythical creature whose flapping wings and forked tongue were thought to create thunder, and lightning.

The animals and symbols in Haida art can mean lots of things, but the two most important animals are the eagle and the raven, representing the two main Haida clans. The eagle can represent power and prestige, as well as peace and friendship; the raven is a trickster but is also charming, representing knowledge and creativity as well as mischief.

Other animals found in Haida art include the Wolf, a skilled hunter and healer; the Beaver, a creature symbolizing revenge; and the Frog, who can represent luck, and bring the wearer money. Guys might choose one of these symbols in the hope that the qualities of their chosen animal will be passed on to them, or just because they like the unique look of Haida art.

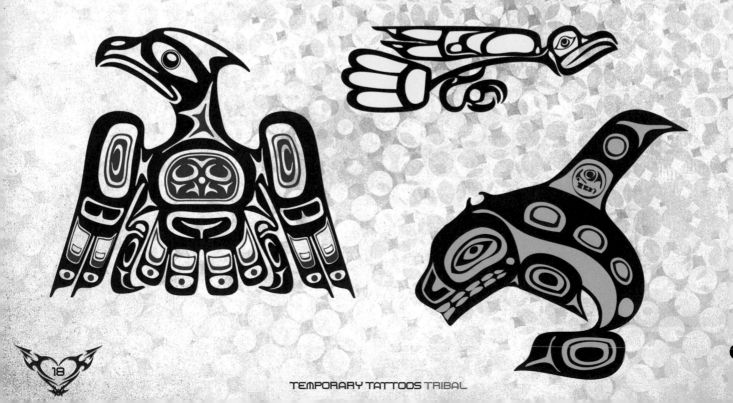

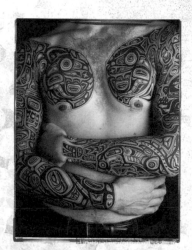
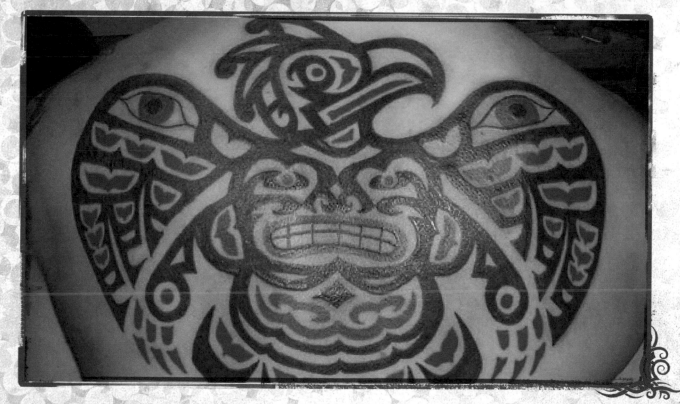

Modern Tribal

The modern style of tribal tattooing has a lot in common with the traditional styles it has evolved from. You'll see lots of bold black designs that can look quite fierce, with sharp edges and overlapping shapes—but the designs might include elements from many different traditional tribal styles.

For example, a striking black spiral tattoo might be a mix of Maori and other Polynesian styles, or you might see an eagle (symbolizing qualities like strength and bravery) drawn in a tribal style. In fact, any image—from anteater to zombie—can be drawn as a tribal-style tattoo. Whatever the design, there's no mistaking the modern tribal tattoo, and it's popular with guys all over the world.

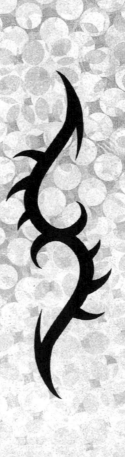

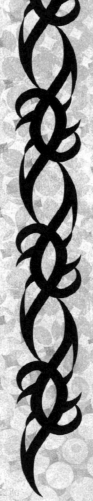

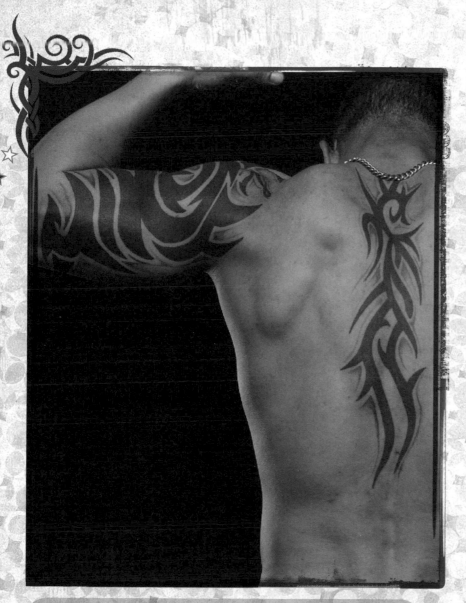

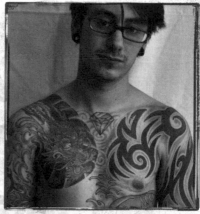

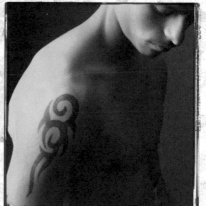

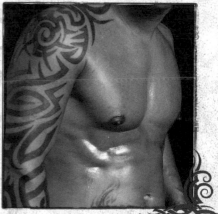

PART OF THE TRIBE

One of the original reasons for tribal tattoos was to show a person belonged to a tribe, or a family. Modern tribal tattoos can be just the same: people wear them to show they're part of a sports team, a band, or a member of the armed forces. Sometimes friends or family members choose the same design so they can share that sense of belonging. We all have our tribes, and our tattoos can help us show it.

LETTERING

Sometimes people want their tattoo to say something very specific—so they'll literally spell it out. Tattoo script can include names, phrases, words, or numbers, and comes in many different styles. Guys might get them as a memorial, as a sign of their religion, or they might want the lyrics to their favorite song or quote—like Martin Luther King's "I have a dream," for example, or the Beatles' "All you need is love."

There's no need to limit yourself to English, either: tattoo script can be in any language. Whatever you choose to say, lettering makes a real statement, and can carry a lot of meaning.

LOVE

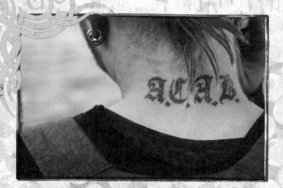

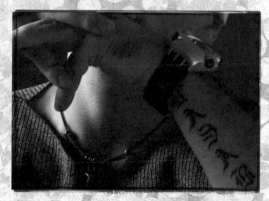

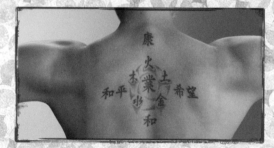

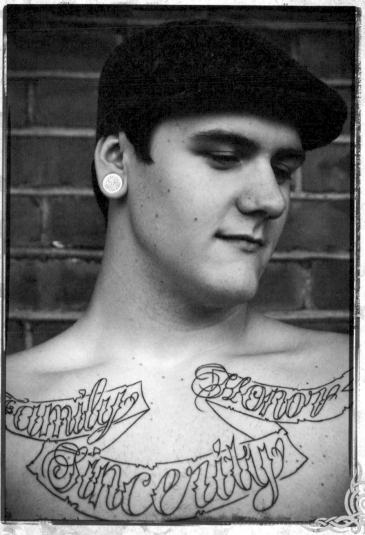

PLACEMENT

Some guys like to proudly display their memorial or religious tattoos on their wrists and forearms where they're easy to see; some might like the kanji for "Warrior" on their biceps to make them feel stronger; others might want to keep quotes, poems or mottos secret, and wear them on the upper arm, legs, or even the feet, where they can be covered up. Experiment, and see what feels right!

Words & Phrases

Guys might choose words as a memorial or to show love for their family. The classic Old School (see pp. 46–53) tattoo of a heart with "mother" underneath is a good example: soldiers going away to fight overseas in World War II wanted to remember their families at home, and their tattoos helped them do that. The idea is still popular today—guys choose it to remember loved ones who have died, or to show respect and love for the living.

Religious phrases, poems, quotes from movies, and song lyrics are all popular choices as well, helping people find the right words to express themselves.

Often you'll see words combined with a strong image, to make the message even clearer. Other languages (Spanish, Italian, French) are very popular, too. People might choose another language to symbolize their homeland or heritage, or because they think it sounds good (some people think Italian sounds very musical, for example), or even to make the meaning a little more mysterious. Latin is a very popular choice, and gives words a timeless quality, perhaps because it's an ancient language found in the oldest books and manuscripts.

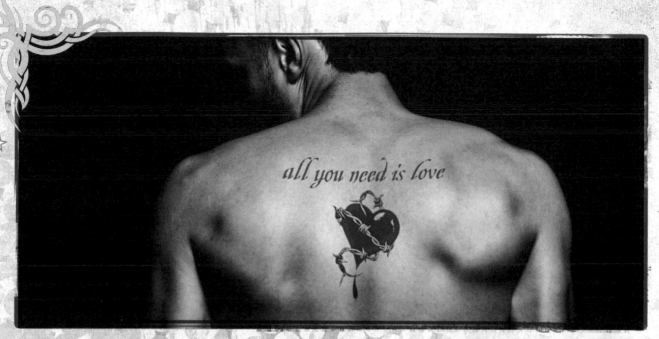

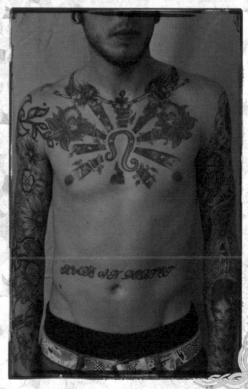

SCRIPT STYLES

With tattoo script, the design is just as important as what it says.
You might go for a heavy gothic style to add weight to a phrase,
or a more gentle handwritten style for names, for example. Angry
words might have a spiky style, or religious ones something more
classical. There's a style of writing to fit every phrase, and make it
more meaningful to the wearer.

Kanji & Chinese

Kanji are Chinese symbols that are used to write Japanese. There are three kinds of Japanese alphabet—kanji, katakana, and hiragana—although kanji is the most popular for tattoos (it's actually one of the most popular kinds of tattoo as well).

Guys might choose kanji or Chinese symbols that represent bold, simple, and strong ideas that they would like to embody—"Eternity," "Warrior," "Peace," or "Wisdom." They're very distinctive to look at, and can vary from very neat little symbols to beautiful pieces that look like they've been painted on. Because they're so

hard to read, so ancient, and from the Far East, kanji can also have an exotic feel to them.

One warning: we know what our temporary kanji tattoos say, but be careful with real ones. The same kanji can mean different things in different situations, even changing meaning depending on who reads it, so obviously guys need to take their time when they pick a design to make sure they choose something that actually makes sense... (Guys don't want the kanji for "Idiot" on their wrist instead of their names. Well, not many guys, anyway.)

Eternity (Kanji)

Warrior (Chinese)

Love (Chinese)

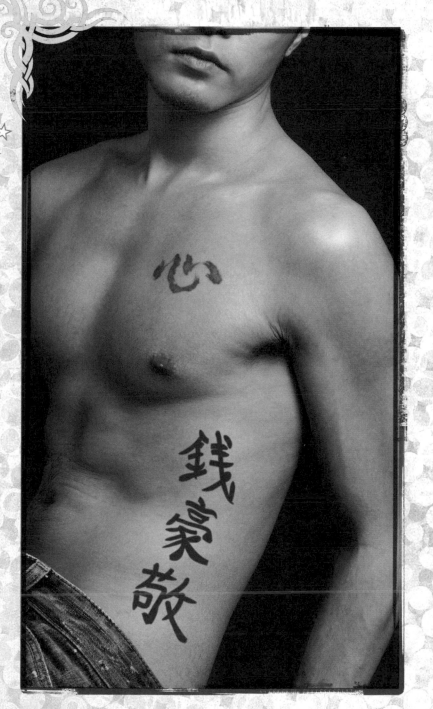

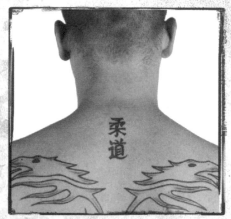

Sanskrit & Arabic

Sanskrit (an Indian language) is mainly used in Hindu and Buddhist religious ceremonies and texts. Sanskrit tattoos are striking and beautiful to look at—they're chosen by guys who want to bring elements of Buddhist or Hindu faith into their lives, like "Purity," "Karma," or "Nirvana," or who just want to have their ideas expressed in this ancient language.

Arabic calligraphy is still considered an important art form, and is used for inscriptions, poetry, and writing verses from religious texts such as the Koran, the holy book of Islam. The elegant script is read from right to left, and might be used for tattoos of single words, like "love," "king," or "freedom," or for longer quotes from Koranic scriptures as a sign of a person's faith.

Both Arabic and Sanskrit tattoos can also act as protective images. They're great for guys because the script can work as an armband, which can help define muscles, and make the wearer look toned, but it's important to think about where to place any tattoos based on holy texts. They should always be placed high up the body, nearer to the head and heart, to avoid offence, and to make sure the mantras, chants, etc. actually work.

Peace

Lucky

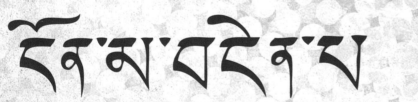

Ultimate Truth

ॐ ॐ

Ohm

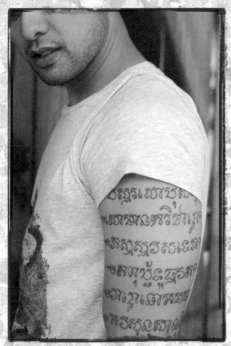

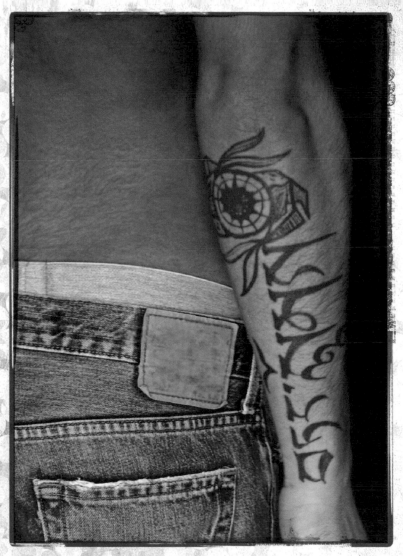

MORE LETTERING

There's a whole world of lettering out there to try out: ambigrams are designed to look like the same word, no matter what way round you view them (good for playing Twister); invented languages like Elvish from the *Lord of the Rings* and Klingon from Star Trek are popular; there are cattle brands, Egyptian hieroglyphics, Greek...the language of tattoos is almost infinite.

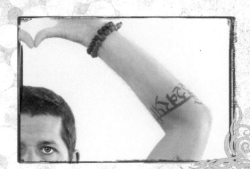

SKULLS

When you see a skull grinning back at you, what do you feel? Afraid? Nervous? Does it remind you of death, horror movies, maybe even pirates? Skull tattoos are designed to create all those responses, and more.

A skull is instantly recognisable as something that was once human, and alive, so obviously it can remind us of death. But it can also remind us that under the skin we're all the same, put together the same way. It can be a reminder to live a good life, because we'll all die in the end; or even an image symbolizing triumph over death. When you put on a skull tattoo, you can feel the meaning in your bones...

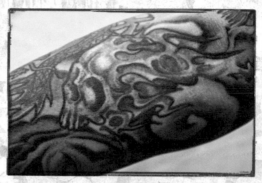

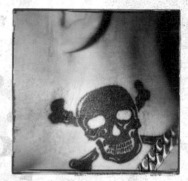

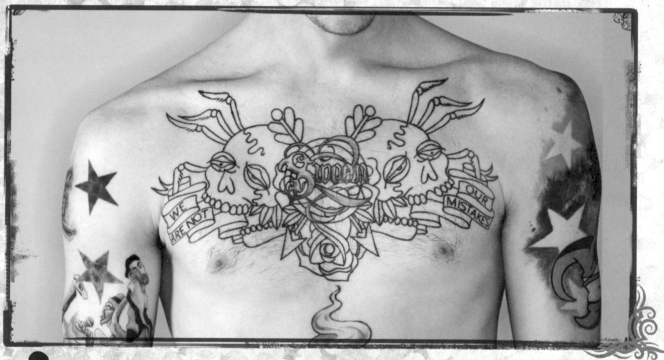

PLACEMENT

Skull tattoos are potent symbols, so there's no point hiding them. They'll look great on the arms and forearms, where you can easily display them, and also on the shoulders or back (where they can look behind you to scare people away).

SCARY SKULLS

When we see skulls in movies, it's usually time to be afraid. They've been used throughout history to show triumph over the enemy, and to frighten people: by wearing them, drinking from them, even by sticking criminals' skulls on spikes as a warning. The death's head—a skull with crossed bones behind it—was the intimidating emblem of the Nazi SS in World War II, and we use it now to represent poison, so the skull has been a frightening symbol for a long time. Some guys get skull tattoos to look scary. Simple as that. There are very few images more intimidating than a really sinister-looking skull tattoo, and guys can make them more frightening by adding color, weapons, blood, or by displaying them in a really prominent place. Nothing says "don't mess with me" like an evil skull soaked in blood! (Apart from maybe a big pile of evil skulls soaked in blood.)

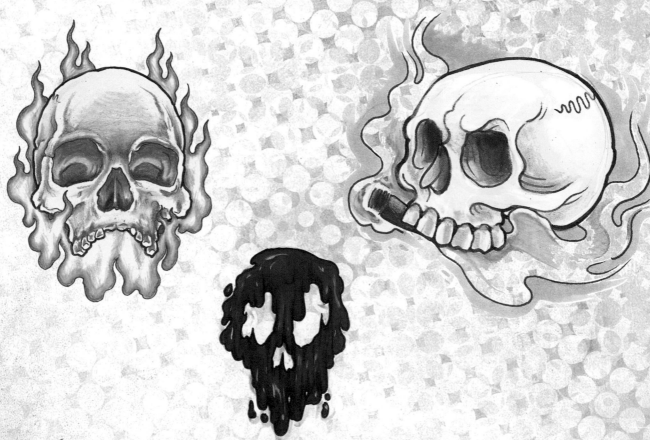

SKULLS & SERPENTS

Far from being a grisly image, a serpent crawling through a skull is an ancient symbol for knowledge and immortality. In the nineteenth century, skulls combined with roses could also represent eternity, immortality, and resurrection. Both images are popular tattoos, quite often in the Old School style (see Chapter Five).

LIFE & DEATH

Because we all end up as bones, and the skull is the easiest part of the skeleton to identify as human, it's not surprising that they've become symbols of death in many cultures. Choosing a skull tattoo can show an awareness of death, and that it's something that happens to everyone.

That doesn't have to be a morbid idea, though. An awareness of death can also be a reminder to live a full life, so some guys get skull tattoos to make sure they enjoy every moment before the end. Skull tattoos can also represent cheating death or overcoming it—so people might have them to help conquer their fear, or to celebrate surviving a life-threatening event when death smiled at them, and they smiled right back.

Because skulls appear in various religions, on tombstones, temple carvings, and in religious art, some people also wear them to symbolize the idea of life after death.

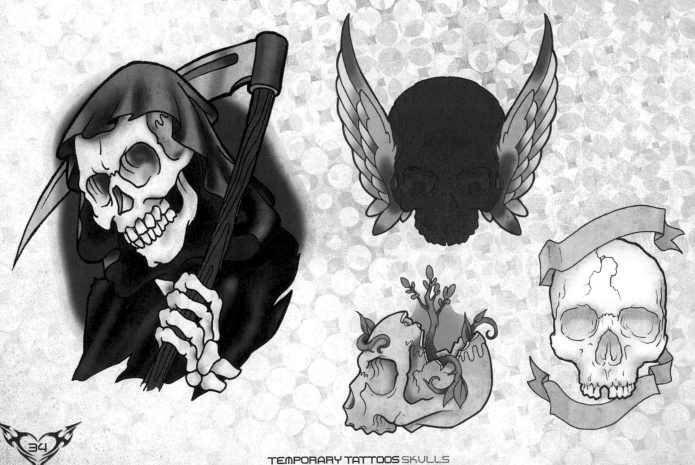

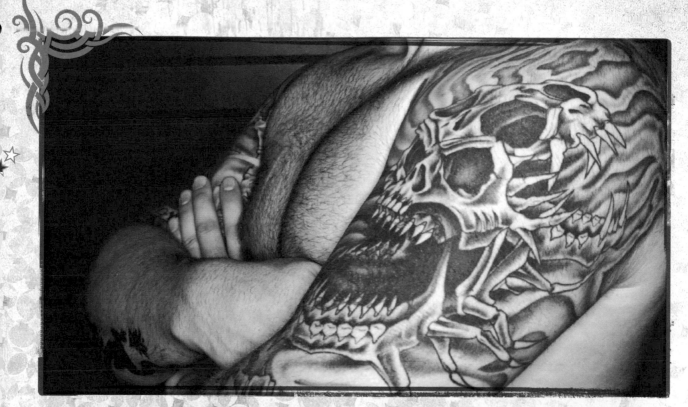

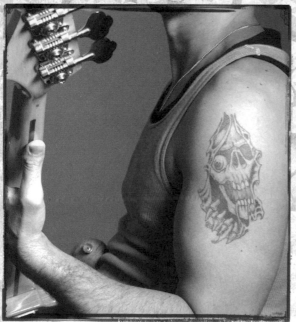

Pirate Skulls

Historically a ship flying the skull and crossed bones flag was crewed by pirates. The flag was a message to any ships they were attacking: the pirates were not afraid of death, and would fight without mercy until they got what they came for. It was designed to strike terror into sailors and make them surrender.

Pirate-style skull tattoos on guys can symbolize the swashbuckling life of someone who lives outside authority and won't obey the rules. They can also be a sign of bravery and fearlessness, saying that the wearer won't give up on their battles, and isn't afraid to fight when they need to.

Pirate skulls can also look mischievous, and show the wearer has a wicked sense of humor—a grinning pirate skull doesn't have to be be scary, it can also be funny, and show that a person doesn't take things too seriously. Or that they're a pirate, of course.

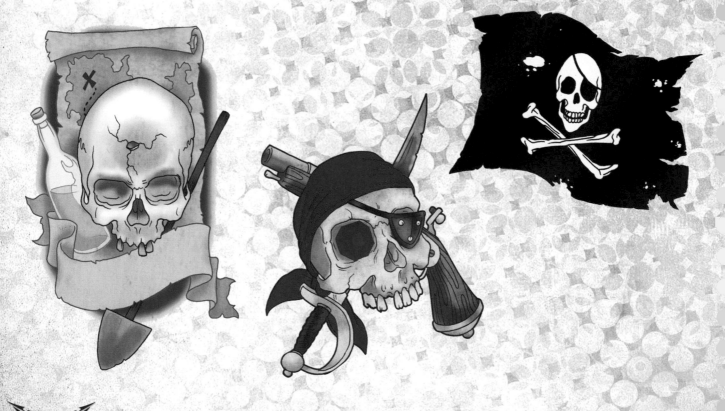

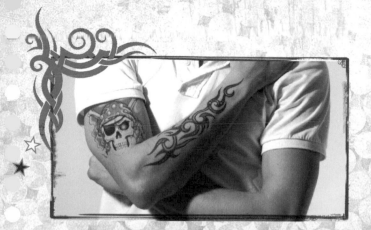

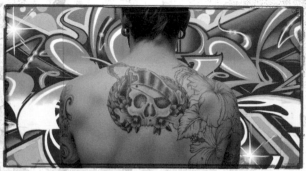

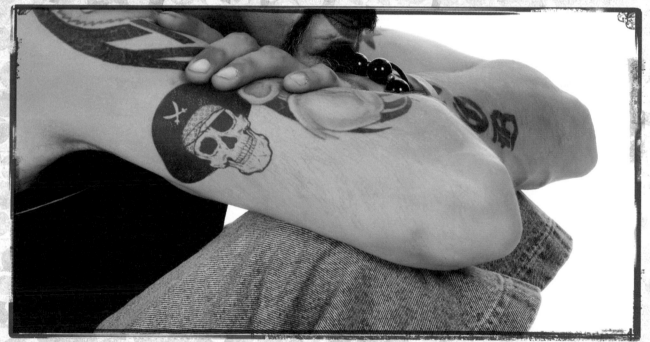

THE JOLLY ROGER

Although it was traditionally the symbol of pirates, the skull and crossbones flag—or Jolly Roger—has since been flown by Royal Navy submarines as a symbol of their stealth and bravery. They have displayed it as they sailed into port, celebrating their safe return and victories. So you might even find sailors wearing Jolly Roger tattoos...

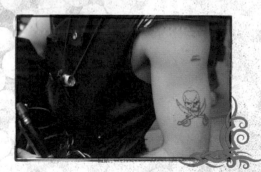

WILD CATS

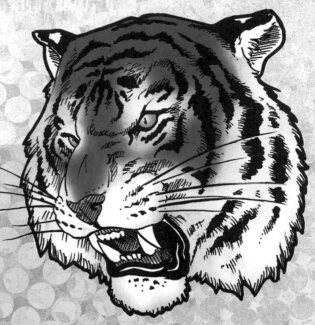

W ild cats have been important to many cultures throughout history. In the past, wearing claws, teeth or the fur of a wild cat was thought to give the wearer some of the animal's abilities—but you might not want to wear a leopard's skin in the street, so a tattoo has a similar function. Wild cats are fierce, swift, cunning, strong, and proud, so guys might get a wild cat tattoo to show they have some of the same qualities.

With their reputation for strength and speed, it's no coincidence that wild cats have made their way into martial arts—tiger, panther, and leopard are all styles in kung fu, and many professional fighters sport large wild cat tattoos, much like the ancient warriors who first wore the animals' teeth and claws.

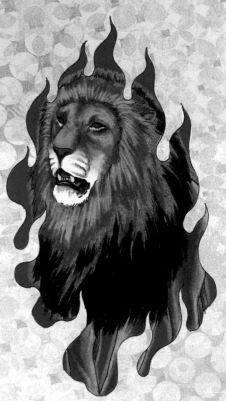

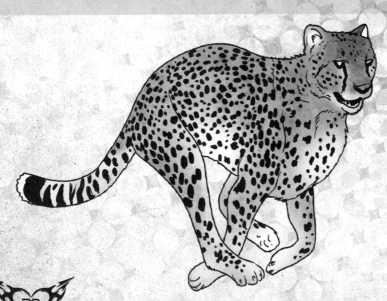

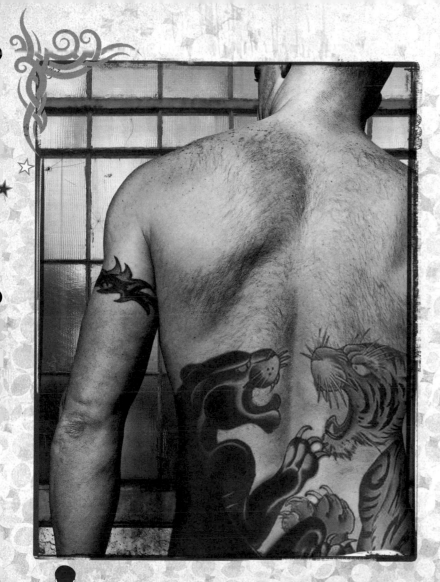

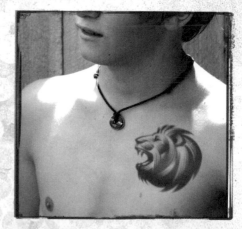

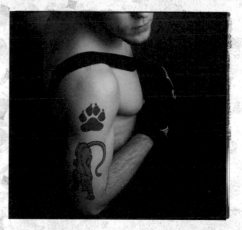

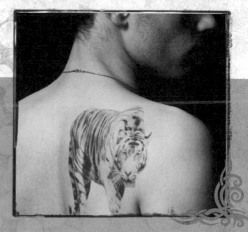

PLACEMENT

Wild cat tattoos look best when they're placed on the upper arms or across the shoulders and back. They make guys look bigger and more muscular, as well as strong, agile, and fast, just like the cats themselves. You might try them with other designs, too—they work well with Dragons in Japanese tattoo styles, so mix and match.

LIONS

Lions are important symbols all over the world, appearing in European and African culture as well as Chinese and Japanese art and mythology. Lions stand for the sun, courage, justice, strength, nobility, victory, authority...you name it. Lions are leaders of their prides, and in charge of protecting them, so guys might also wear lion tattoos as a protective charm, or if they want to be a leader, and look after others.

Lions can equally be seen as vain, proud animals that must be mastered as a rite of passage before boys can become men (this was particularly true for some African tribes), so you might choose one to show you've conquered the lion within, and are ready to face the world on your own. African mythology also saw lions as symbols of creation and destruction, so a lion tattoo can recognize the two opposing forces at work in the world.

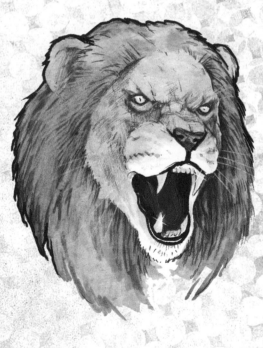

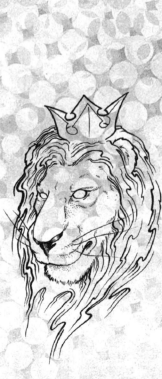

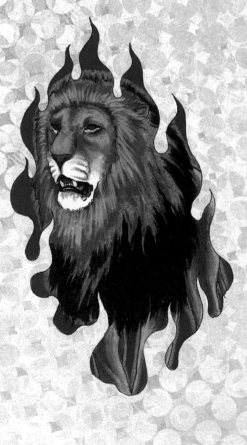

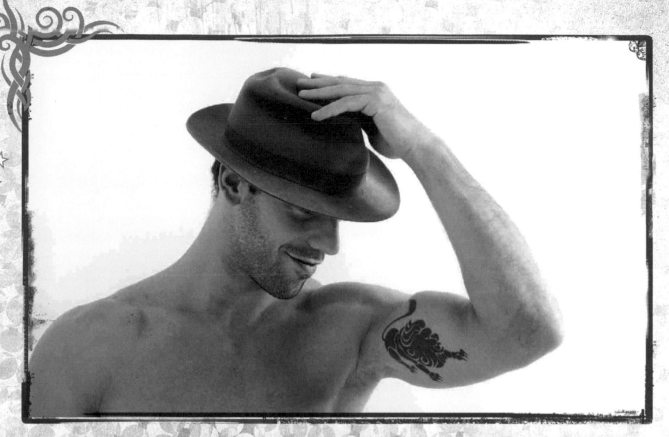

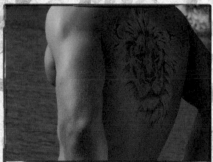

THE LION KING

Lions are regarded as King of the Beasts, and the royalty of the animal kingdom. Because Christ was also referred to as the "King of Kings" in the Bible, lion tattoos can also represent Christ for some wearers. Lions can also symbolize Buddha, the Hindu god Krishna, or Kings and Queens.

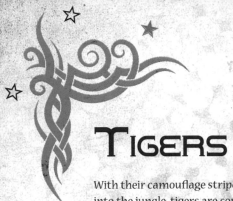

TIGERS

With their camouflage stripes to help them blend into the jungle, tigers are complex creatures that represent stealth, hidden power, ferocity, wrath, and even cruelty. Choosing a tiger tattoo is all about wanting to look tough and fierce, or perhaps showing that you can be both beautiful and deadly, nice and nasty, just like tigers.

Tigers have an intimidating physical presence that can be even more fearsome than the lion's. In tattoos this presence can scare people (or evil) away, just like images and statues of tigers do in China. Guys wanting a symbol of life, death, or destruction can also turn to the tiger, which represents all of those things.

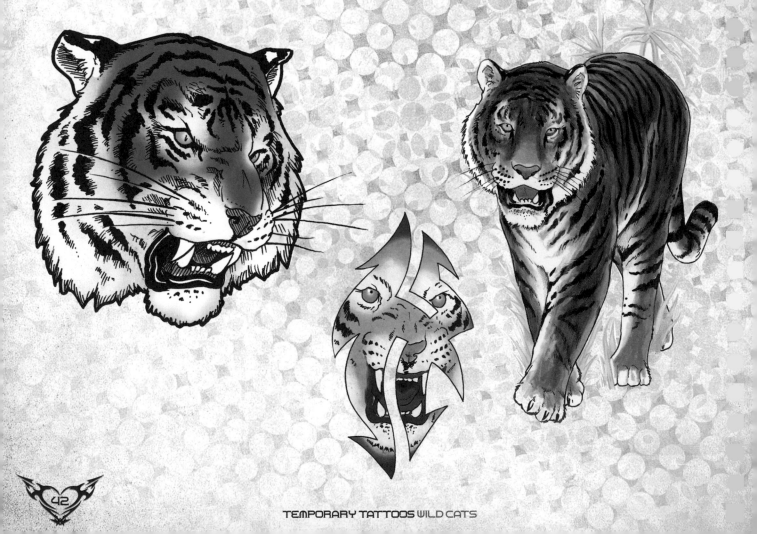

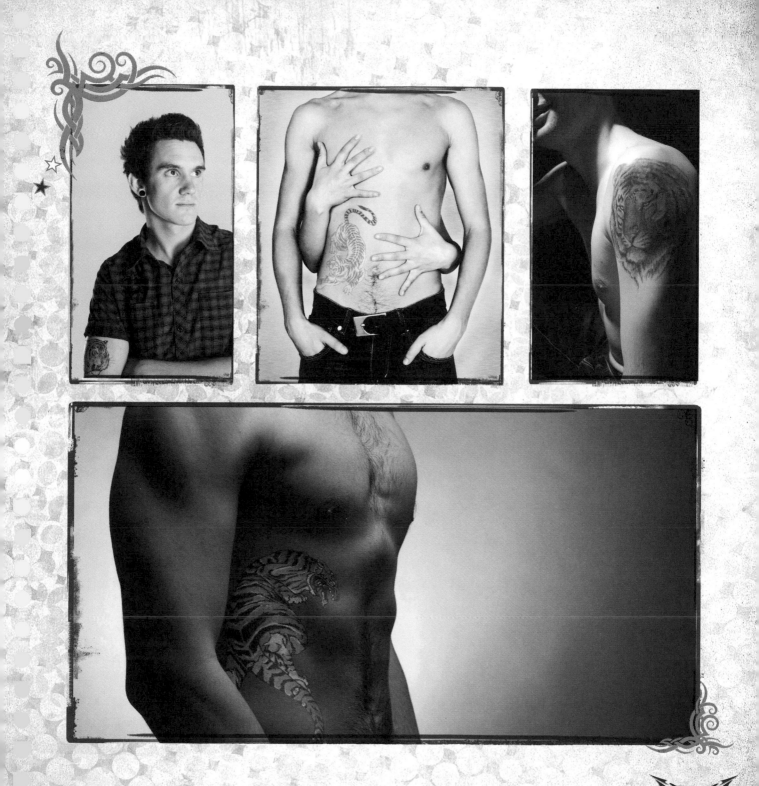

Jaguars & Leopards

Leopards are nocturnal animals with a secretive, mystical quality that has made them revered as sacred for thousands of years. Leopards are immensely strong for their size, and are formidable hunters—guys wear leopard tattoos to show strength and courage, as well as the patience and endurance of the hunter. Snow leopards, found in mountainous regions of Asia, are solitary animals living largely alone, so a snow leopard tattoo might show someone is independent and mysterious. The jaguar was the god of the underworld to people in South America, so it has strong magical properties and connections to the spirit world. Jaguars are skilled at hunting in all conditions, day and night, so can be used to show skill in battle—not just war, but any struggle. Guys looking for a noble symbol of ancient magic can't do better than the jaguar.

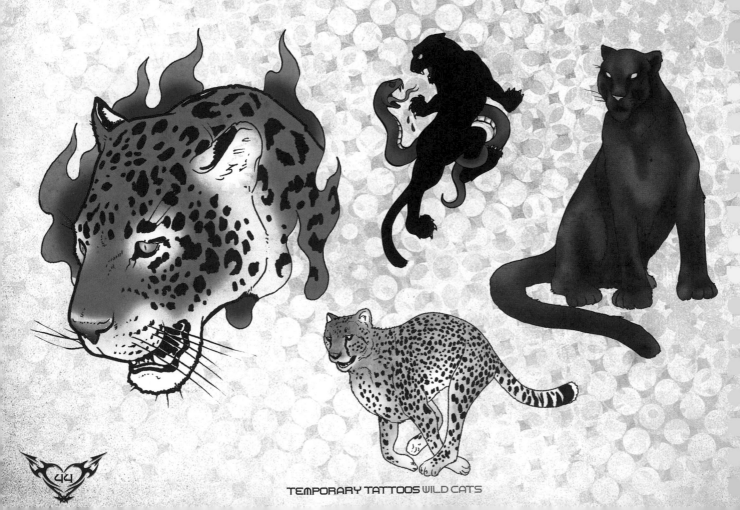

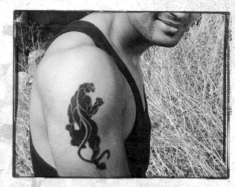

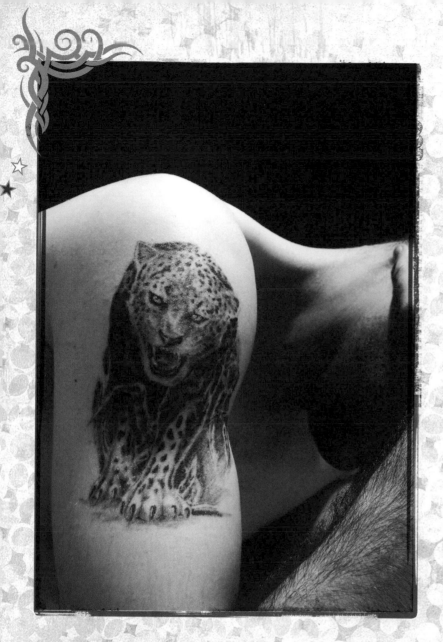

MORE CATS

Of course, there are lots of other cat tattoos with different meanings: panthers (standing for rebellion and sensuality), and cheetahs (speed and insight) are other wild cats; there are also housecats, which symbolize magic, independence, and evil or good/bad luck (if it's a black cat).

OLD SCHOOL

Old School is right at the heart of tattoo culture. It describes a traditional American style made popular by artists like Norman "Sailor Jerry" Collins, who was inspired by his trips to Polynesia in the early twentieth century. Old School tattoos are bold and bright with designs closely linked to the sea, vice, luck, and symbols of individual freedom—sailing ships, dice, daggers, and eagles are all common images.

Old School's classic style is just as important to some guys as the symbolism, and they might pick an Old School tattoo simply because it fits with their own look. Others might wear one that has a specific meaning to them, like membership of the armed forces. Either way it's a flexible, great-looking style with a real sense of humor and fun that has stood the test of time—no wonder it remains popular after all these years.

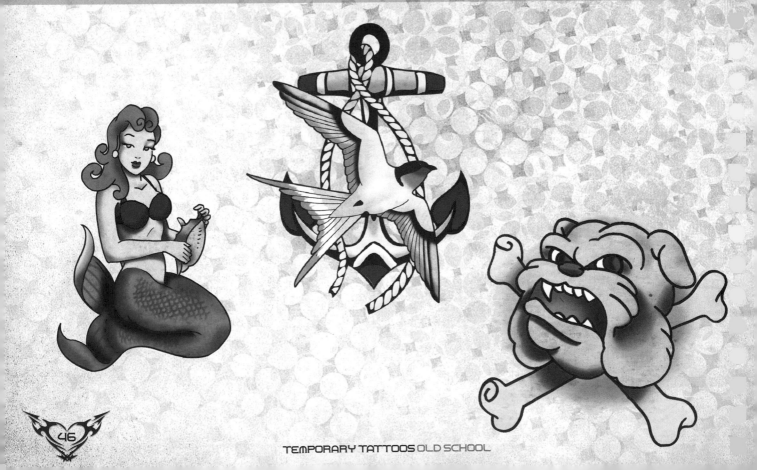

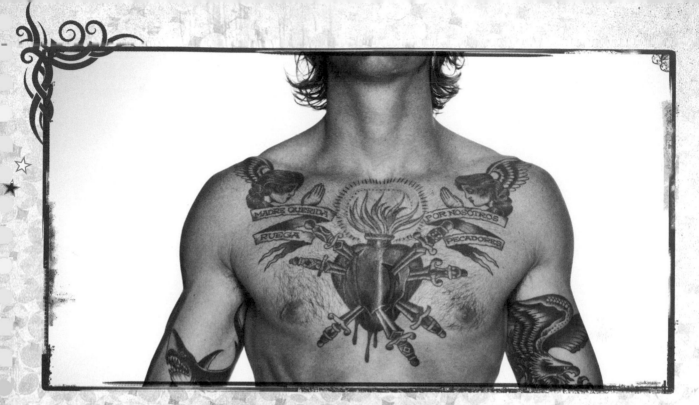

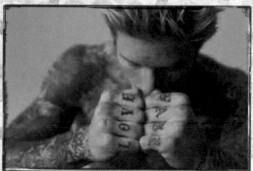

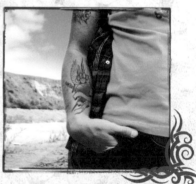

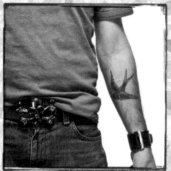

PLACEMENT

Old School tattoos tend to be worn on the arms and shoulders. Images like anchors and nautical stars are often worn on the forearms, with other designs looking best on the upper arms. Horseshoes can be worn pointing up or down, depending on your belief—pointing up catches good luck; pointing down pours bad luck away; or pointing down spills the good luck. You decide! Larger symbols like eagles and flags can go across the back or chest, and pinup girls are best where you can keep an eye on them...

Nautical

Nautical tattoos are about as Old School as it gets—they go right back to the start of modern tattooing, when sailors would wear them to show where they'd been, or what a life at sea meant to them. These days guys wanting to go to sea might choose a ship tattoo, a swallow (symbolic of life, death, good, and bad luck, but more importantly being close to dry land), or maybe an anchor or image of a pirate.

Nautical tattoos are popular with guys wanting to join the Navy or who love the ocean, but they can represent other things too. An anchor can also show that you're rock steady, and won't be moved by the storms of life, just as a real anchor keeps a ship safe in the harbor. Ships can also represent an adventurous spirit, so they're good for guys who want to get out, and see the world. Another classic design is the nautical star: sailors used to navigate using the heavens, so it could be a good luck charm to help you find your way in life, and protect you if you're lost.

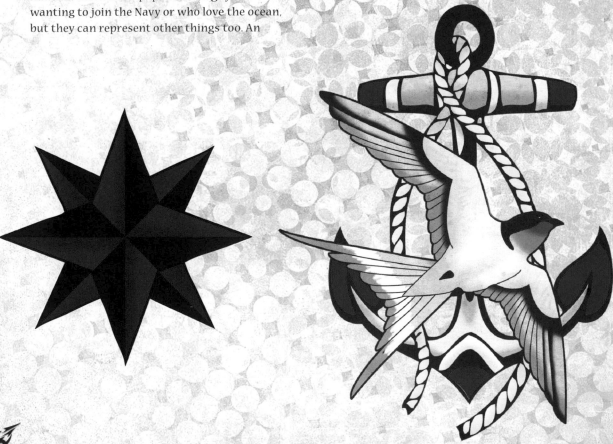

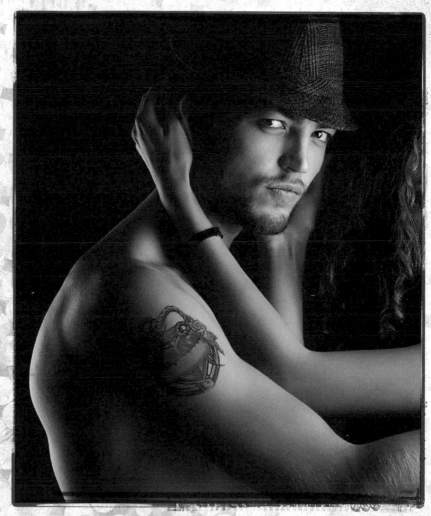

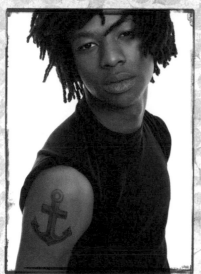

WHERE HAVE YOU BEEN?

Old school nautical tattoos were used by sailors to show the voyages they'd made, and can be used by guys for the same thing. Ropes show you've crossed the Equator, International Date Line, and Arctic and Antarctic Circles. Dragons represent journeys to China, turtles represent the equator, and if you're worried about falling into the water, a shark tattoo will protect you from being eaten by the real thing!

Luck & Ladies

Images associated with luck and fate make great Old School tattoos. Guys wear tattoos of dice, horseshoes, or playing cards (like the Ace of Spades or the Joker) to remind them that life is unpredictable, and to expect the unexpected. They might also choose lucky dice or card combinations to bring them good fortune, or even to warn them of the perils of gambling or taking too many chances.

Pinup girls can be associated with chance—luck is often referred to as a lady, after all—but they have other meanings too. They're attractive, of course, and might remind guys of a loved one, or they might warn them to stay away from certain kinds of girl! Pinup girls are fun and cheeky, but can have a serious purpose too: they have appeared as mascots on planes and ships in the armed forces for years, to protect people, and bring them back safely. (It's the one kind of pinup girl your mom won't mind you bringing home.)

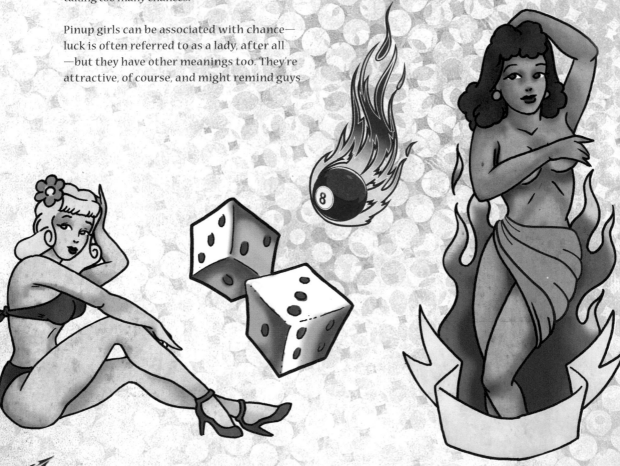

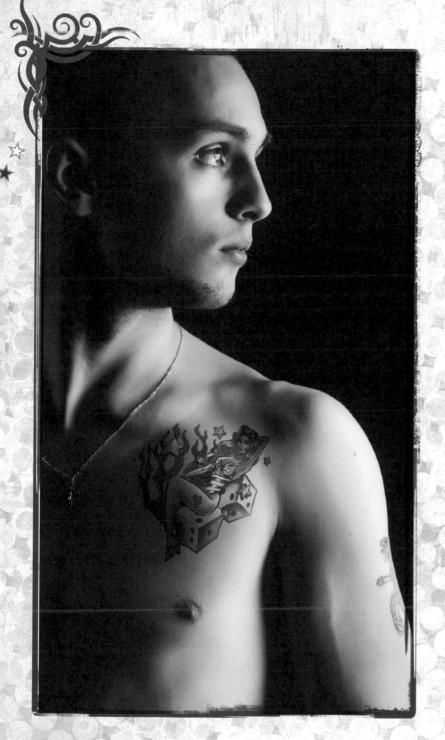

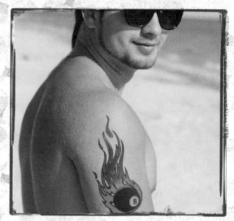

Bikers & Outlaws

Tattoos of Harley Davidsons, skulls, Hell's Angel flags, etc. were popular amongst biker gangs from the birth of Old School tattoos, and remain popular to this day. Wearing this kind of tattoo can show you're a member of a biker gang, but they also point to a personality that dares to be different. It's a tattoo for tough, independent individuals.

Motorcycles and hotrods are symbols of speed and thrills, so work well for guys who love adrenaline and want hi-octane adventures. They've also been symbolic of freedom in movies and books, so wearing a bike or hotrod can also mean you cherish your freedom or want to get out on the open road and see as much as you can.

Certain makes of car and motorcycle can also be closely associated with particular countries, so they might be worn as a patriotic symbol. Harley Davidsons tend to be associated with the USA, for example, or Jaguar sports cars with England—choosing an image of one could show love for your country, particularly when combined with a flag.

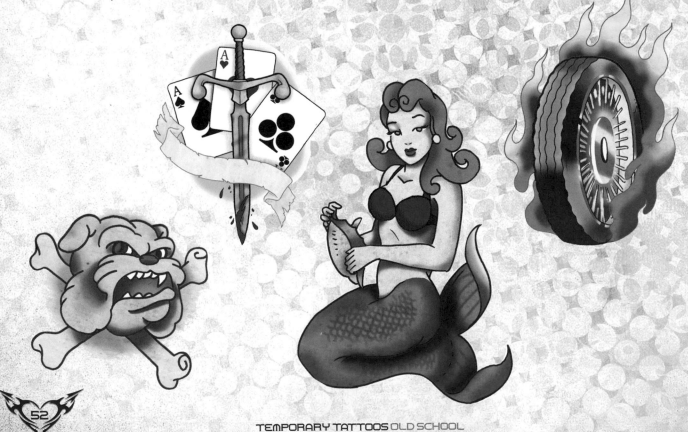

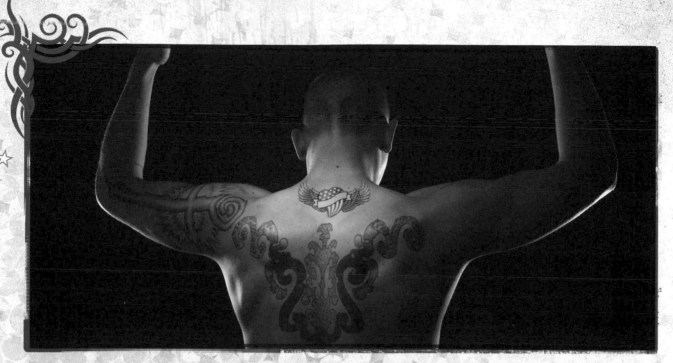

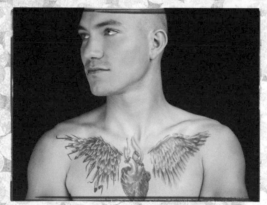
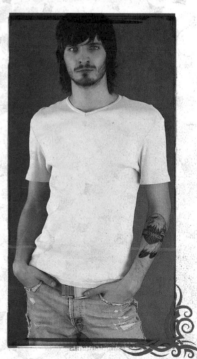

EVEN MORE OLD SCHOOL

There are plenty more Old School designs for guys to choose from. Native American art is popular, as are more patriotic images like Eagles (for the USA), Bulldogs (for England) or national flags. Hearts, cherries, daggers, and mermaids are also common choices for guys, and can be combined with words or phrases to make a really personal tattoo in the classic Old School style.

DRAGONS

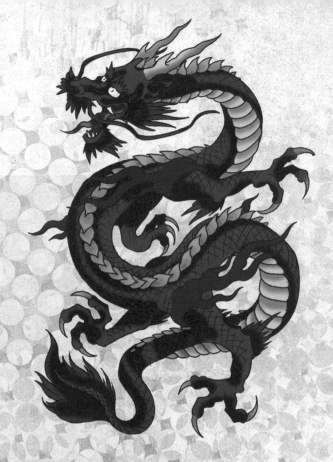

A dragon is probably one of the most impressive and symbolic tattoo designs. Guys like them because of their strength and power—they can make the wearer look fierce—and because of the many things they can represent. Dragons exist all over the world, and different cultures see them in very different ways. To Eastern cultures the dragon is a positive, protecting spirit shaped like an intelligent looking serpent; in Western folklore dragons are terrifying beasts spitting flame and ruin, shown with wings and claws that make them look more like cunning demons.

Dragons are also mythical creatures that are shrouded in mystery—it's no coincidence that ancient maps would use the phrase "here be dragons" to describe unknown lands filled with unimaginable dangers. Dragon tattoos are powerful symbols of wisdom or mystery, courage or fear—there's a dragon out there for everyone.

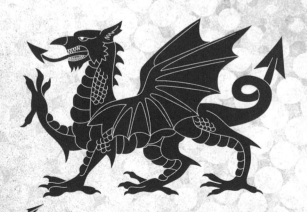

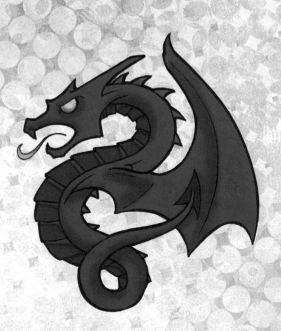

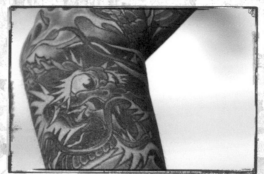

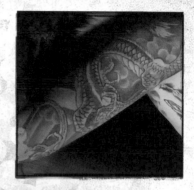

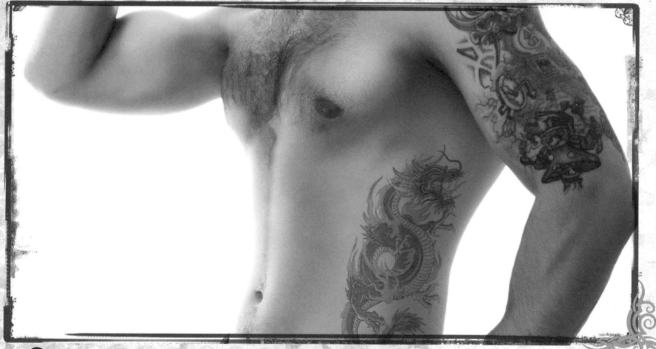

PLACEMENT

Because dragon tattoos can curve around your muscles, they look great on the upper arm or on the back, where they'll make you look more toned. They're strong too, so on the arms they'll make the wearer look more powerful. Japanese yakuza (gangsters) go for elaborate backpieces covering their entire back, with dragons making up a big part of the image, to show they're tough and fearless—temporary tattoos don't come that big, but try a dragon on your shoulder anyway!

Eastern Dragons

In China and Japan, the dragon can appear as a serpent-like creature with talons and a long tail; they usually don't have wings. They can symbolize strength, nobility, imagination, and wisdom, and to the Chinese they are spirits of the four elements (earth, air, fire, and water), and of the four compass points. They show our connection to the elemental forces of nature, which is one reason guys choose them as a tattoo—to recognize our relationship with the world around us.

Dragons in Chinese mythology were said to be shape-shifters, and other creatures were sometimes rewarded for good deeds by being turned into dragons. As a tattoo, dragons can also show the power of transformation, and the potential rewards of trying hard and living a virtuous life. Who wouldn't want to be a dragon, after all?

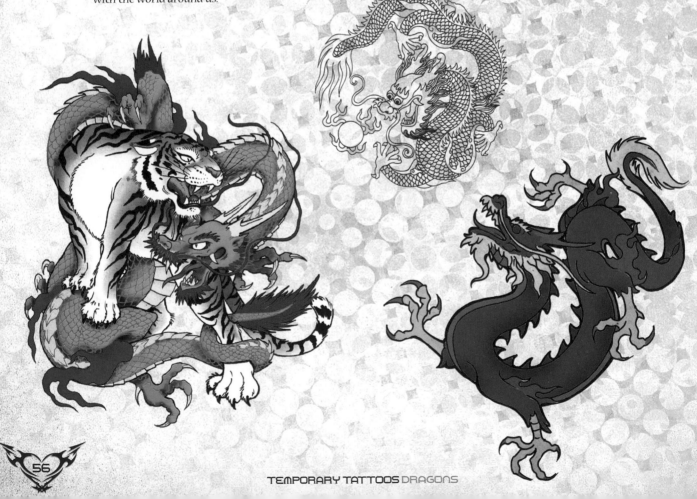

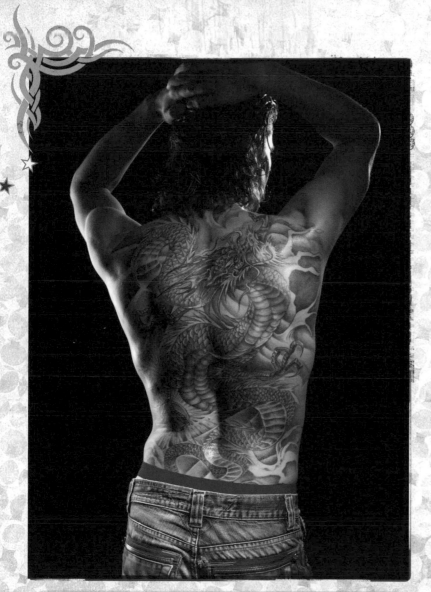

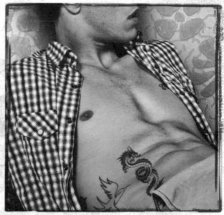

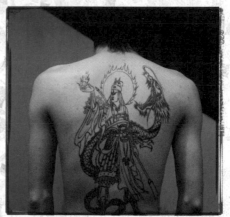

DRAGONS & OTHER TATTOOS

Chinese dragons look particularly good with Chinese tiger designs. It's claimed that the dragon can represent your positive side, while the tiger is your negative, destructive side—if the two are positioned evenly on your body, you're a well-balanced person. However, if the tiger is above the dragon then you can sometimes be ruled by your destructive desires, and if the dragon has the upper hand...well, you're probably lying. No-one is that good.

Eastern Dragons continued...

As well standing for natural forces, dragons are frequently seen as guardians in Chinese and Japanese mythology. They appear in temple carvings, as statues and even on the emperor's robes, to illustrate their protective powers. If people feel that they are protecting something special or have a responsibility to something (or someone), they might choose a dragon tattoo to help show it, and to remind them of it.

Dragons also turn up in the Buddhist religion, where they helped protect the Buddha, and ward off evil spirits. Again, a guy might turn to a tattoo of a powerful Chinese dragon for protection from evil, to represent a belief in Buddhism, or to gain some of the power of the dragon for themselves. Finally, let's not forget that Chinese dragons look really cool—definitely a good enough reason to put one on...

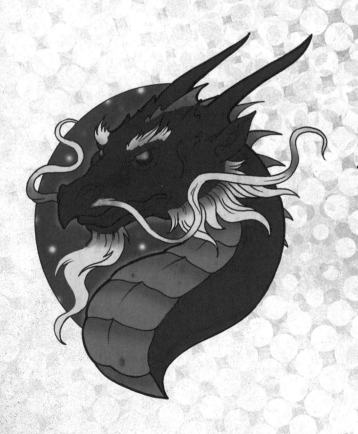

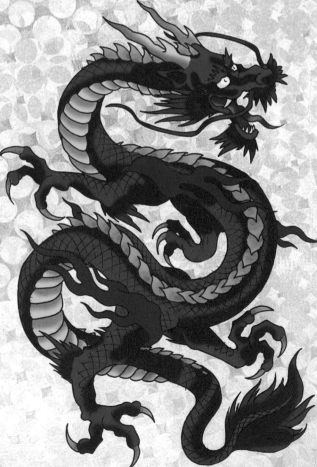

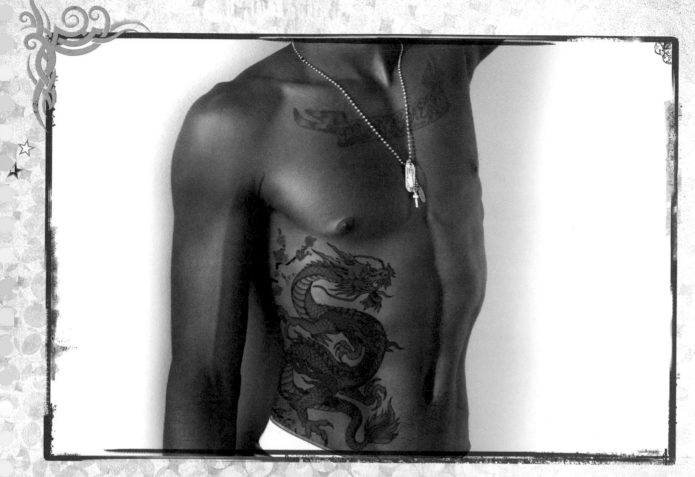

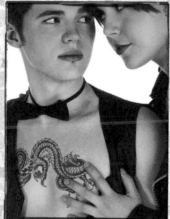

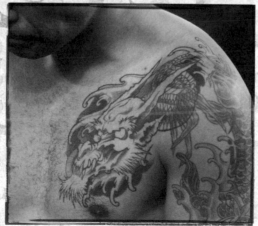

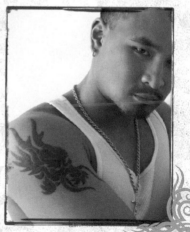

Western Dragons

These beasts are very different to their Chinese cousins, often represented in myths, legends, and fantasy stories (like *Lord of the Rings*) as wicked monsters symbolizing greed, destructive power, and even the power of the King (particularly in Celtic mythology). They have wings, breathe fire, and strike terror into the hearts of anyone who encounters them—only the very bravest knights and warriors will go up against a Western dragon.

However, they're not entirely evil creatures, and some dragons can represent nobility and courage in adversity, like the red dragon of Wales. As tattoos they can embody power, ferocity, a fiery temper, and also cunning, or show that the wearer is a fan of fantasy and magic., and what better symbol to give you strength and protection than an intimidating, fire-breathing dragon? Guys choose these designs to feel more confident, to scare people off, or to look meaner—especially in contact sports like boxing or martial arts.

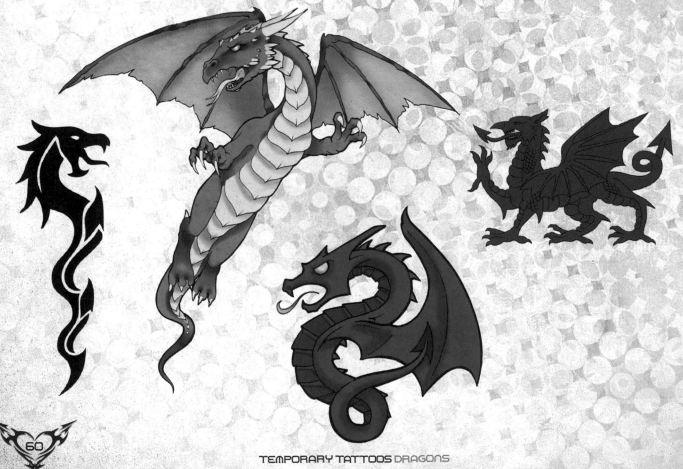

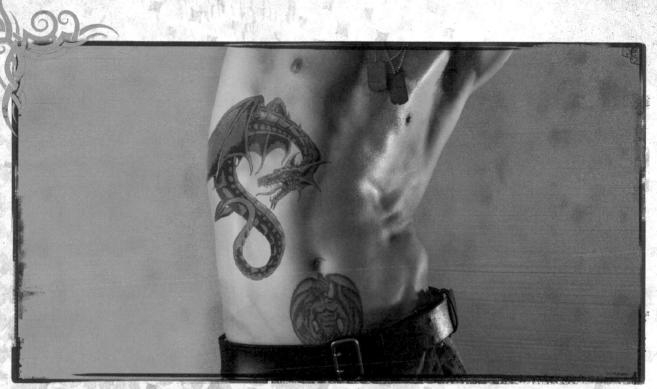

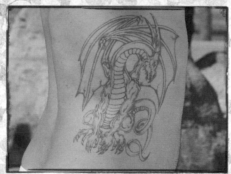

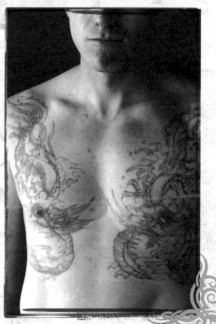

OVERCOMING THE DRAGON

In some European folk tales and fantasy, dragons are defeated by brave warriors. St George, the patron saint of England, famously killed a dragon; St Michael is also seen defeating one, symbolizing good triumphing over evil. As a tattoo this shows someone has the courage to face their dragons, and overcome problems; it may also be a sign of Christian faith.

RELIGION

Religious tattoos are a way of demonstrating your belief and devotion, not only because of their meaning but (in some cases) because the wearer is willing to suffer pain to show their faith. Even the process of getting them can form part of religious ceremonies, particularly in countries like Thailand where monks tattoo the faithful every year at the Temple of the Flying Tiger (Wat Bang Phra).

Wearing a religious tattoo can remind people to live their life according to their faith, or act as a talisman to bring them luck, and protect them from harm. The tattoos can be images, phrases, or symbols like the cross, prayer wheel, or Star of David.

For some cultures tattoos were essential for getting you into the afterlife—almost like a ticket to heaven. Whatever your religion, choosing one of these tattoos is a powerful statement of faith. It lets people know you're proud of your beliefs, and you're happy to show it.

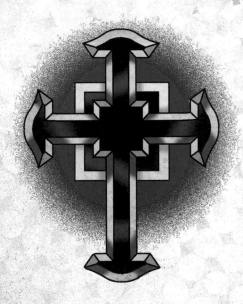

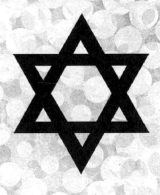

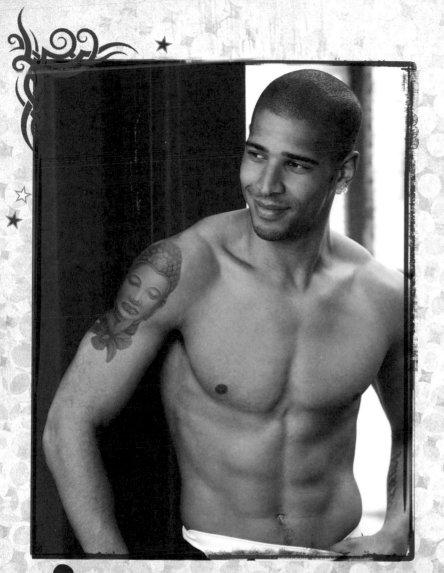

PLACEMENT

Placement of religious tattoos is important so that the wearer gets the full benefits of their powers, and doesn't offend their God or Gods, or any other followers of their faith. Generally it's a good idea to wear them high up on the body, near the head or heart. The back is a popular site as well, particularly for large cross tattoos, as they fit better; you might also try rosary beads or smaller symbols on the wrist.

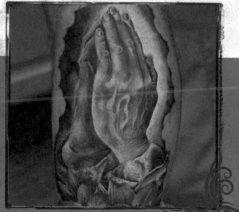

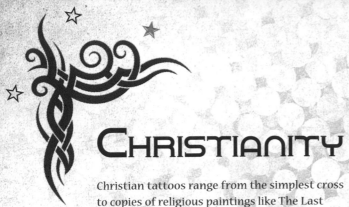

CHRISTIANITY

Christian tattoos range from the simplest cross to copies of religious paintings like The Last Supper. Guys choose symbols that reflect their beliefs or different attributes of God and Christ: a white dove for peace; angels as messengers from God; praying hands as a sign of devotion. Guys might also go for images of the Madonna, rosary beads, a crown of thorns or perhaps a sacred heart.

Images of Jesus are another popular choice. Tattoos might show Christ in a calm position bringing peace and love to his followers; they may show him crucified and suffering; or they might show the resurrected Christ as the ultimate symbol of redemption, and life after death. Wearing this kind of tattoo lets guys express their faith in a clear way—they may also feel that Christ is watching over them, and protecting them from harm.

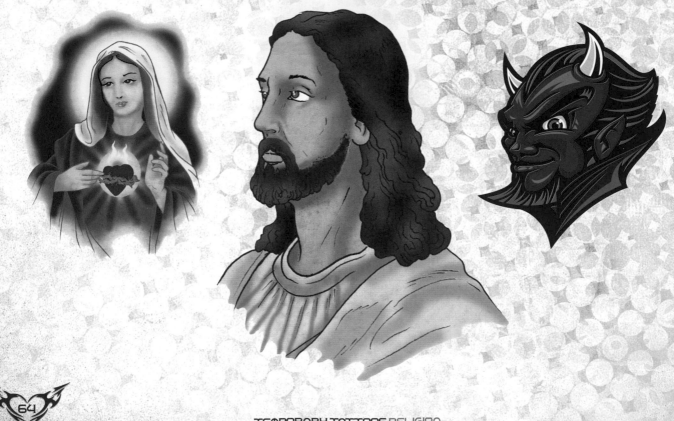

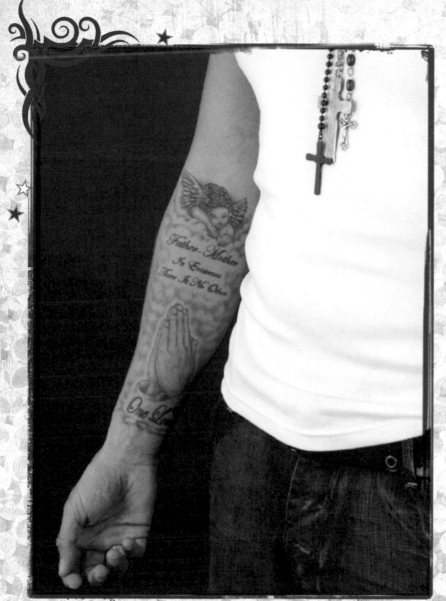

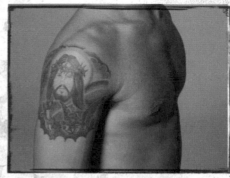

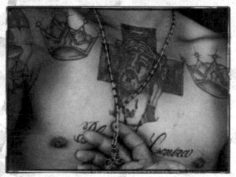

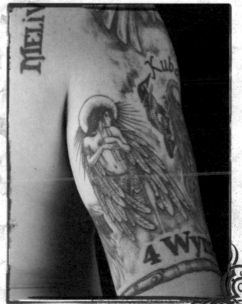

DEVILS & DEMONS

You can't have good without evil, or saints without sinners. Devils and demons are also popular tattoo choices, and can range from the downright scary to more humorous images. They can represent evil, darkness, and temptation, or can be more lighthearted, and show that a guy has a mischievous side.

Western Dragons

These beasts are very different to their Chinese cousins, often represented in myths, legends, and fantasy stories (like *Lord of the Rings*) as wicked monsters symbolizing greed, destructive power, and even the power of the King (particularly in Celtic mythology). They have wings, breathe fire, and strike terror into the hearts of anyone who encounters them—only the very bravest knights and warriors will go up against a Western dragon.

However, they're not entirely evil creatures, and some dragons can represent nobility and courage in adversity, like the red dragon of Wales. As tattoos they can embody power, ferocity, a fiery temper, and also cunning, or show that the wearer is a fan of fantasy and magic and what better symbol to give you strength and protection than an intimidating, fire-breathing dragon? Guys choose these designs to feel more confident, to scare people off, or to look meaner—especially in contact sports like boxing or martial arts.

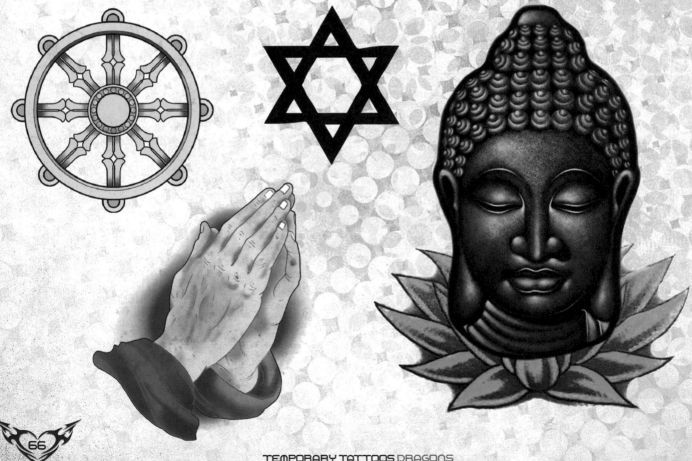

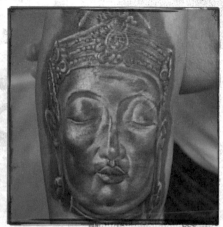

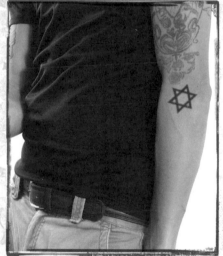

OVERLAPPING FAITH

Muslims believe in Satan, and Adam and Eve in the same way that Christians do, so some religious tattoos overlap—guys can have verses from the Koran as well as Christian symbols to further emphasise their beliefs. Angels also feature in Islam, and are another way of showing faith—they include Gabriel, the messenger of God; and Azrael, the angel of death.

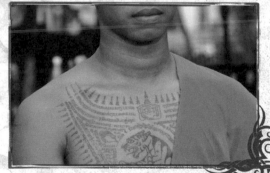

CROSSES & RELIGIOUS SYMBOLS

The cross isn't just a Christian symbol. It's been sacred for countless years, and carries many different meanings: a cross can represent the points of the compass; the four winds; heaven and earth; even the shape of man himself. They can also point to Celtic heritage, or even immortality.

As well as the various types of cross, there are lots of other religious symbols out there to represent someone's beliefs. Christians can choose a fish, or Buddhists might have a prayer wheel. There's also a Shinto shrine, or the striking Taoist "yin/yang" taijitu symbol that shows how everything in the universe is connected and balanced.

Whatever your faith, there's a symbol to represent it, and guys can choose any one of them as a simple statement of their beliefs.

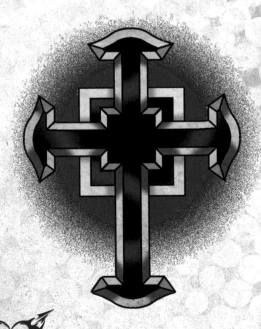

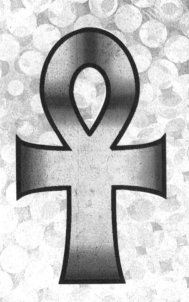

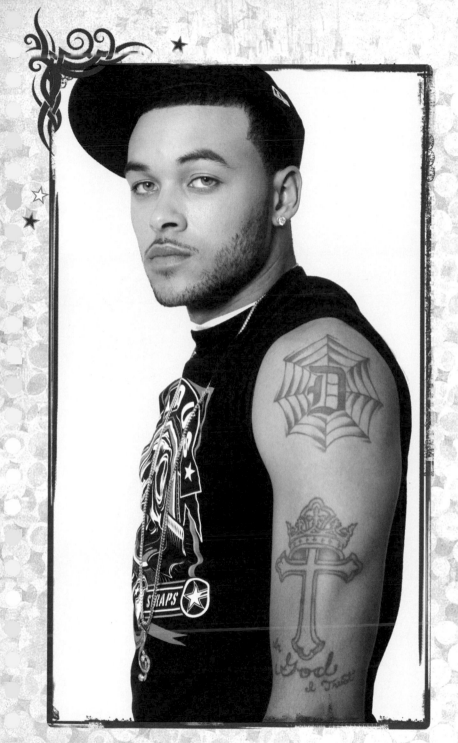

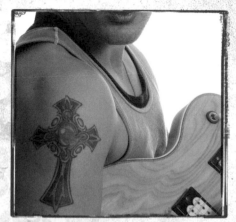

ETERNITY & INFINITY

The concepts of eternity and infinity are important to religions and philosophies all over the world, as well as being essential to science and mathematics. In tattoos they can represent a belief in reincarnation, or illustrate the unending cycle of life or the fact that energy goes on forever (yes, tattoos can even be about Physics). On human skin, which will eventually decay, they can also be a reminder that the universe will continue even when the wearer, or mankind itself, is long gone.

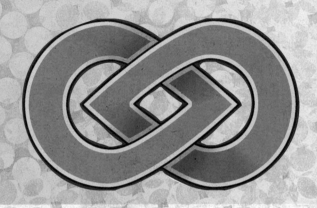

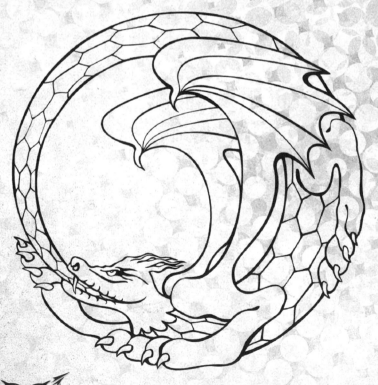

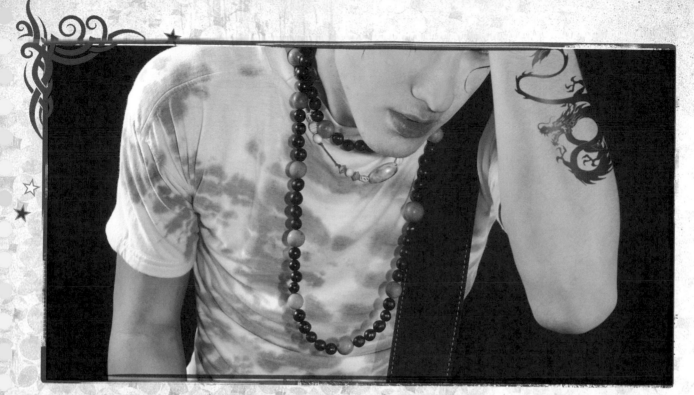

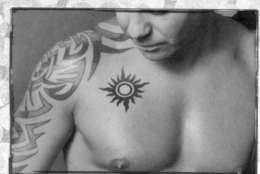

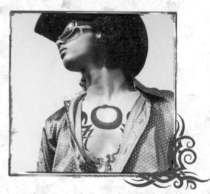

PLACEMENT

Infinity and eternity tattoos look great everywhere, because they're so simple and classic. Good locations are the top of the arms or the shoulder-blades, where their shape will work well. The small of the back is another good place for the same reason. Ouroboros tattoos also work as armbands, so they have the added benefit of helping define the muscles as well as giving the tattoo meaning in three dimensions, instead of two.

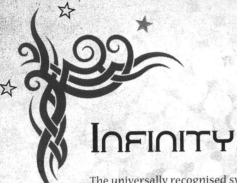

Infinity

The universally recognised symbol for infinity looks like a number eight that has fallen on its side. Originally it was a mathematical idea—a number that goes on forever or is so large it can't be counted, like the number of stars in the universe. Philosophers took the idea and ran with it, so now the concepts of eternity and infinity are part of many religions, and various schools of thought that give you a headache when you try to understand them.

The infinity symbol is a double loop with no beginning or end. Guys might wear an infinity tattoo to show an awareness of the never-ending story of life, or a belief in rebirth. They might even wear it in the hope of living forever, or to show that they know everything will carry on when they're gone—which might be a frightening thought to make them live life to the full, or a comforting idea saying that nothing ever ends.

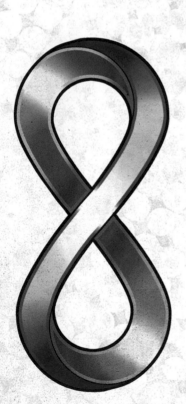

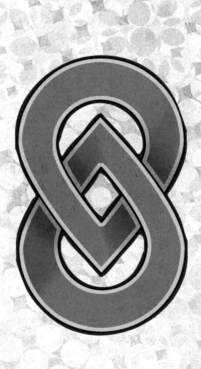

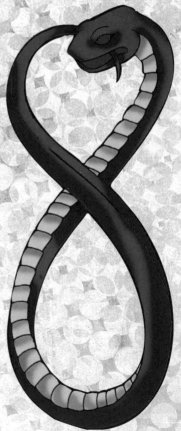

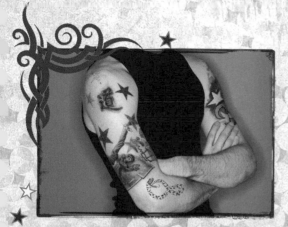

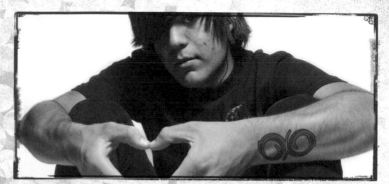

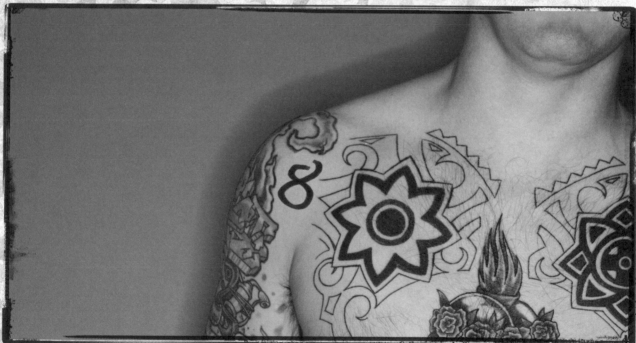

RELIGIOUS & RATIONAL

The infinity loop is both a religious and a rational idea, with roots in maths and science as well as religion and philosophy. It's a tattoo design that can be worn by guys who might otherwise never agree on things—scientists and priests, philosophers and physicists—because they can all recognize we live in a universe of infinite ideas and possibilities.

Circles

For such a simple shape, circles are certainly stacked with meaning. They're all around us—the sun, moon, stars, even our eyes are perfect circles. They could be a way of showing order in chaos—even in a wildly unpredictable world, there's still the smooth perfection of a circle occurring naturally, everywhere we look.

Circles have no beginning or end, so again they illustrate eternity (we have wedding rings to symbolize being together forever), and a sense of everything being whole and complete. They can

be simple designs or complex Celtic knotwork, but guys wear them to show calm, order, and inclusion—we all want to be part of the circle, or better still, inside it.

Circles exist as protective symbols as well, creating sacred spaces to keep bad things out, or good things in. They are wheels to show endless motion, clock faces—even halos. A circle tattoo is a great way for guys to recognize eternity, and many other things.

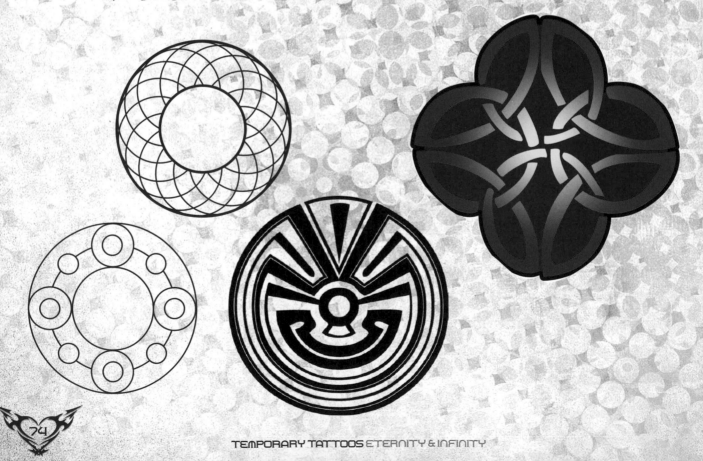

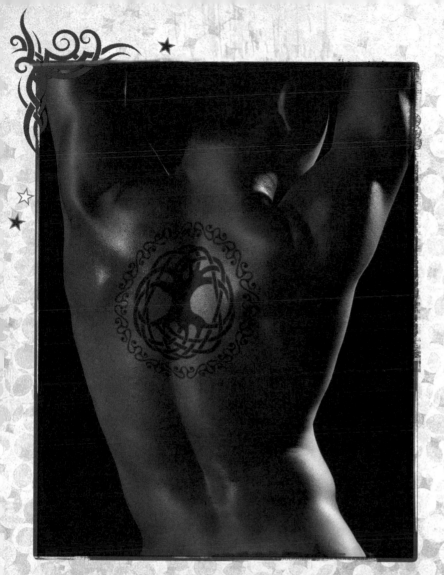

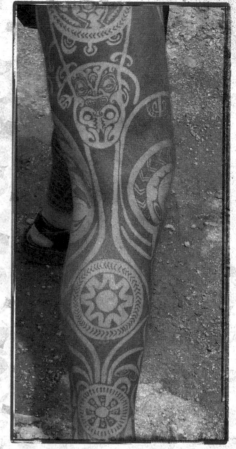

CIRCLES EVERYWHERE

Circles appear in other designs, adding meaning to them. Celtic crosses sometimes include circles, adding to their significance; an 'A' for 'Anarchy' slashed across a circle shows a breaking of order by chaos. Zen circles represent the whole universe in a single brush stroke, and are fiendishly difficult to draw (try drawing a perfect circle freehand in one motion, you'll see), so a tattoo of one must be an exact copy of a painting or the significance is lost.

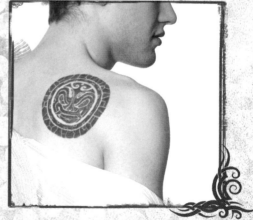

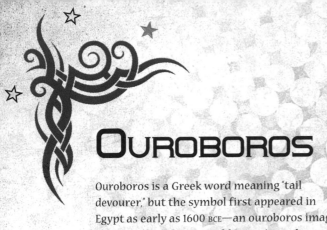

Ouroboros

Ouroboros is a Greek word meaning "tail devourer," but the symbol first appeared in Egypt as early as 1600 BCE—an ouroboros image was even found in Tutankhamun's tomb—and has appeared in cultures throughout the world, from Norse mythology to Hinduism.

The serpent eating its own tail represents many things, including eternity. As it eats itself it creates itself, and always moves forward, symbolizing the cyclical nature of the universe:

things are created, destroyed, created again, and so on. Ouroboros is life out of death, infinity, life without limits. It's also a pretty cool design with a huge number of variations (big snake? Little snake? Plain snake? Diamond-encrusted pimped snake?) so guys might choose one to show infinity in the way that best suits their personality.

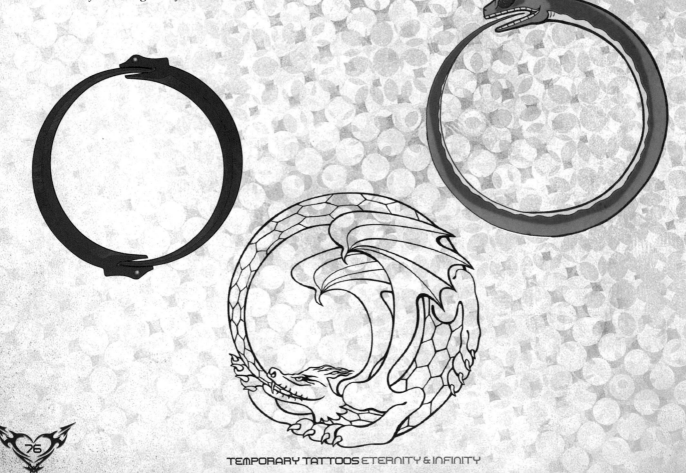

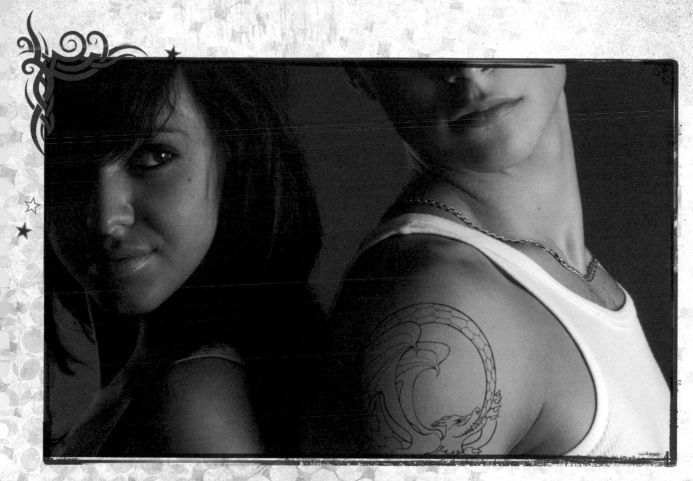

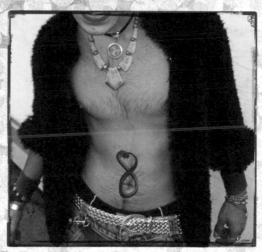

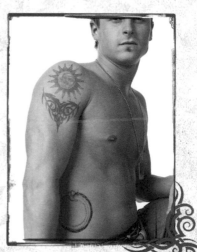

INSECTS

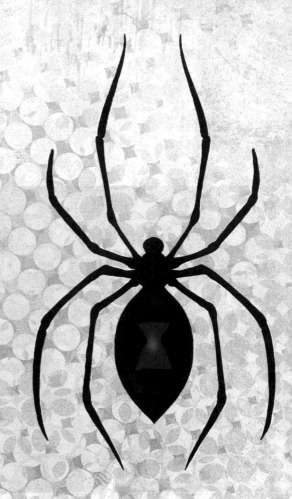

Insects have got us outnumbered. There are hundreds of thousands of different species, with new ones discovered on a regular basis. As tattoo designs they offer a huge range of choice and meanings—they can be deeply symbolic, like scarab beetles; frightening, like scorpions; or colorful and decorative, like butterflies or dragonflies.

Insects disturb and fascinate us at the same time—we do call them creepy crawlies, after all—so seeing them on a person can be a pleasant surprise or a nasty shock. They can be worn to show harmony with the natural world, and a fascination for life in all its forms, or simply because insects are so amazingly, deeply weird.

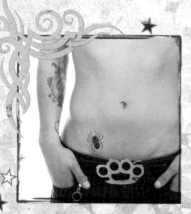

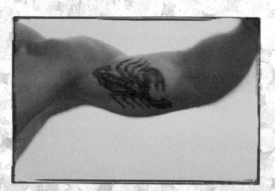

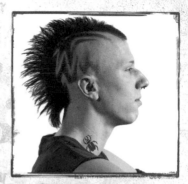

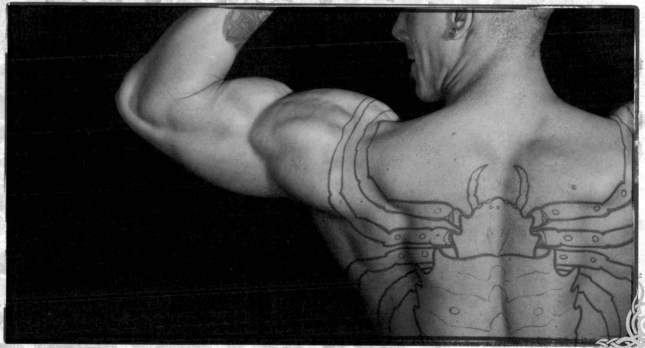

PLACEMENT

Everywhere! Insects can crawl up your leg, sit on your foot, march up over your shoulder, hide in your armpit (if you must), spin webs on your back...you name it. Placement of insect tattoos can be funny, like a column of ants trundling up your leg, or more serious, like a ferocious scorpion on your forearms or a scarab over your heart for protection.

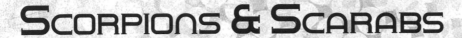

Scorpions & Scarabs

Armor-plated, equipped with pincers, and with a sting in the tail that can kill people, it's hardly surprising that scorpion tattoos are used when guys want to look mean. The scorpion can symbolize death, danger, and pain as well as strength, so it's definitely one to warn people you mean business. On the other hand, a scorpion tattoo can also act as a talisman to ward off evil, and when used to represent the star sign Scorpio it can mean that a guy is honest, intuitive, and a good friend.

Scarab (or "Dung") beetles roll their balls of dung along the ground, and put them in holes, then lay their eggs in them. To the ancient Egyptians the rolling ball represented the sun's journey over the sky, so scarabs became sacred symbols representing the sun. Because the sun sets every night but reappears the next day, they were also symbols of resurrection and the cycle of life, often found keeping mummies company in their tombs. Guys might choose a scarab for luck, protection, as a sign of the sun's power or as a symbol of rebirth. Scarab designs with wings were used to persuade the gods of the underworld to let you in, so a winged scarab could also act as a free pass to the afterlife!

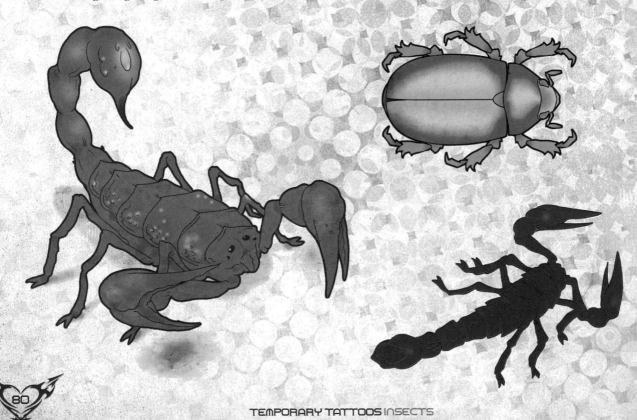

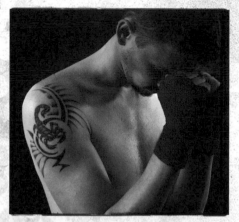

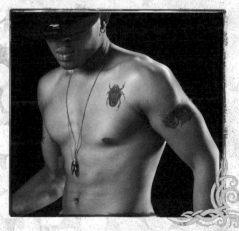

WEIRD & WONDERFUL

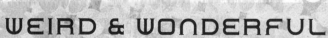

Some insects are too strange to be true, and make great tattoos for just that reason. A praying mantis is a good example, looking like a spindly monster from another planet. Locusts are nasty-looking creatures up close, as are hornets or ferocious beetles with horns or huge pincers. They can all be fun, strange tattoos that make people jump—but they'll always want a closer look.

Spiders

Spiders seem almost magical, with their ability to spin webs, and the incredible variety between species, from giant bird-eating spiders to tiny, deadly black widows. They can jump, run, build traps, hide, and even play dead to avoid capture. Guys might choose them as a tattoo because of their appearance—lots of people are afraid of spiders, and they can look frightening with all those legs, hairs, strange black eyes, and jaws.

Fear isn't the only thing a spider represents. They can also stand for artistic skill thanks to their web-weaving abilities, and in the Scottish legend of Robert the Bruce a spider came to symbolize perseverance: the King watched a spider try over and over again to build a web, until it succeeded, and inspired him to continue fighting the English. Some spiders wait on their webs for prey, and can represent patience, or cunning; others are seen as lucky when dangling at the end of their thread. Guys choose spider tattoos for any of these reasons, or because spiders are agile, nimble, and always look intriguing.

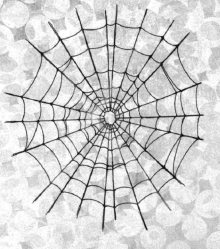

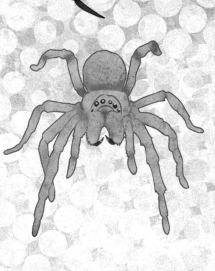

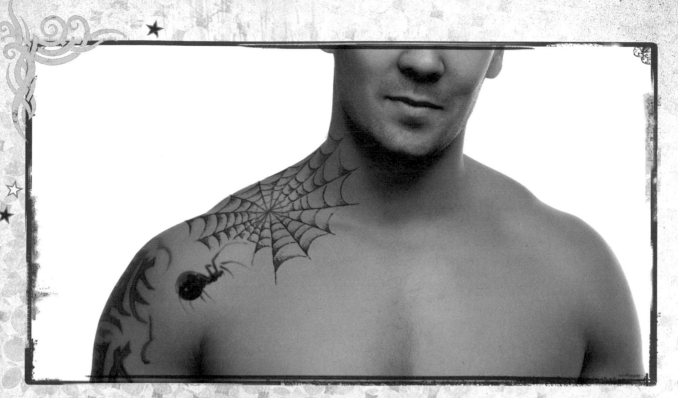

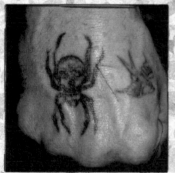

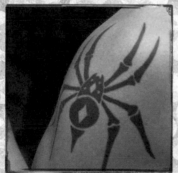

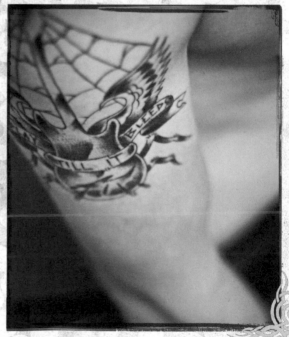

SPIDERWEBS

Spiderweb tattoos are a way of showing you feel trapped by something. They can also have a Gothic look or create a spooky feeling when seen draped all over the body. Webs might show you're aware of the potential traps in your life, too, or that there are things you want to escape from., and of course they're good homes for a spider tattoo. But be aware that spiderwebs on the elbow can mean you've been to prison.

Flying Insects

The most popular single tattoo design is the butterfly, and it's not one that's only for the girls. Butterflies represent the soul, and are an emblem of change, and were used in the past as symbols by warrior priests in Mexico, and samurai in Japan, so there's no reason they can't be a masculine tattoo as well as feminine one.

Similar to butterflies, moths have a slightly darker feel when it comes to tattoo designs. They're nocturnal, so carry the idea of night with them, and tend not to be as colorful. Moths have been used as frightening symbols in movies like 'Silence of the Lambs'—it's hard to deny that the Death's

Head moth, with its skull pattern on its back, is pretty spooky. Guys might go for moth designs to show change, that they're prepared to chase the light no matter what (like moths flying at flames), and also for a scary look.

Bees are generally positive tattoo symbols. They can represent order (because of their organized hives, and system of collecting pollen), hard work, and even the soul—which always finds its way home. Because they hibernate over winter then reappear in spring they're also a colorful symbol of rebirth. But don't forget—they can make things sweet, but bees can also sting; just like life!

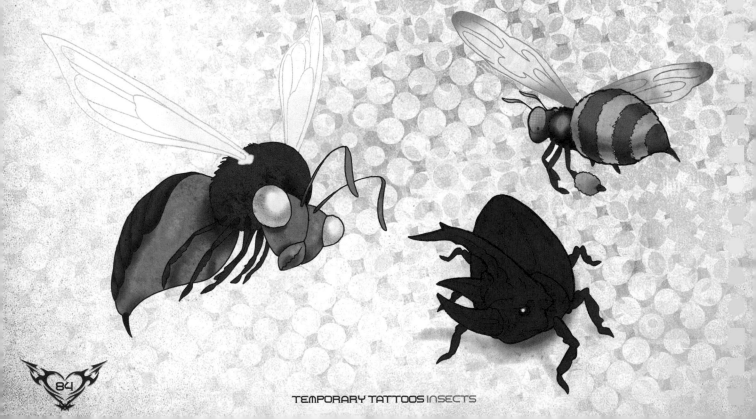

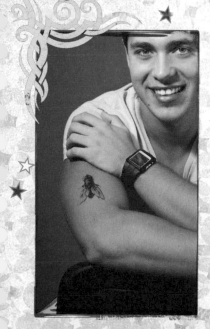
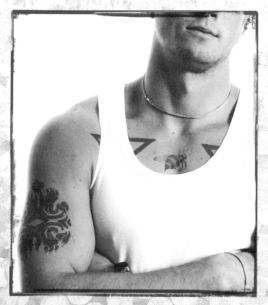
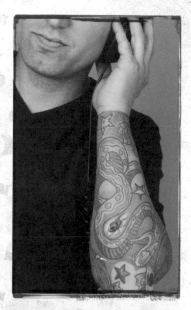
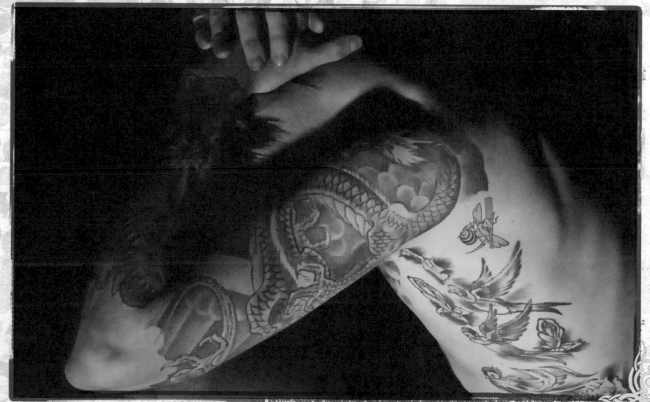

MYTHICAL CREATURES

Dragons aren't the only mythical beasts to stroll out of legends and into tattoo design. There are many others from all over the world, and from every part of history, that feature regularly in the artwork guys choose.

Mythical creatures are popular because of the wide range of meanings they can have, and because the designs themselves are so varied. Choose your monster: Gargoyle? Troll? Vampire? If it's weird and frightening you're looking for, this is the tattoo style for you. Equally, if you're after something protecting and noble, you don't need to look further than the Foo Dog, or Lion of Buddha. Then there are unicorns, winged horses... our rich cultural history can provide you with a fantastical creation for any occasion.

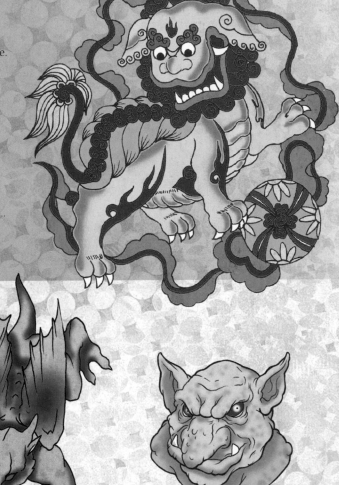

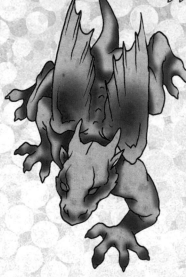

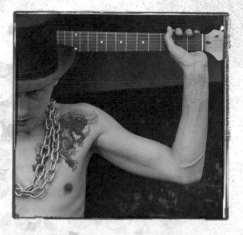

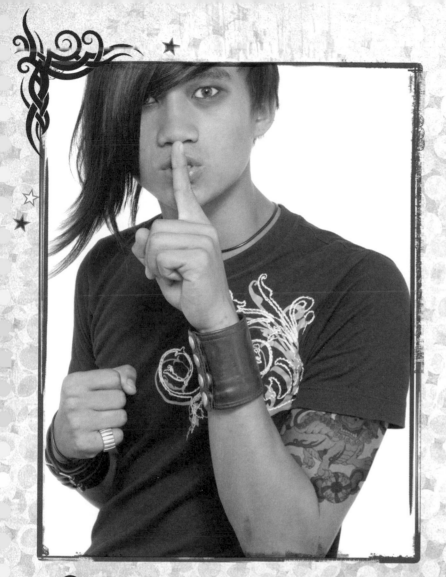

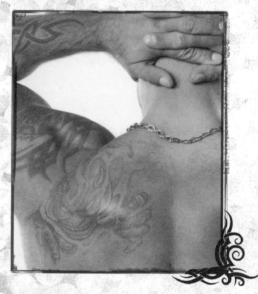

PLACEMENT

Guys wear mythical creatures in different places depending on what they are. Zombies and vampires might be bursting from the chest or leering from the arms for maximum scariness; gargoyles might perch on the shoulders to stare evil spirits down; foo dogs often prowl down the arms or back, keeping watch. Like dragons, they can highlight muscle tone as well, making guys look more toned. Any mythical beast is sure to make a big impression, so wear with pride!

Gargoyles & Grotesque

From ancient medieval churches in Europe to the top of New York's Chrysler Building, gargoyles have been perched on our rooftops for hundreds of years. Historically they've had many functions—the medieval faithful couldn't read, for example, so gargoyles existed as a carved illustration of the good qualities they should encourage, as well as sins and vices they should avoid. They were based on corrupted images of animals, each symbolizing something different: Dogs (loyalty/temptation), Wolves (guardians/greed), and Lions (sun/pride), were common ones, as were combinations of animals (known as Chimera).

Modern gargoyles tend to be more demonic with wings, hunched backs, and ugly faces. Gargoyles are gruesome and fierce, and as tattoos they fulfil the same function as their carved cousins: frightening away evil spirits, and keeping our sacred structures (in the case of tattoos, our minds and bodies) safe. They do this by scaring them with their fearsome appearances, or by camouflaging the wearer so that they blend in amongst the demons. Far from being a symbol of wickedness, guys choose gargoyle tattoos to protect themselves or to represent the virtues they want to encourage, and the vices they want to avoid. (Or vice-versa for some guys, of course...)

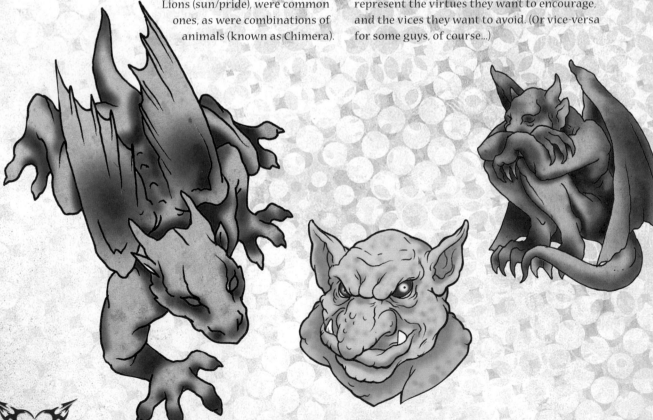

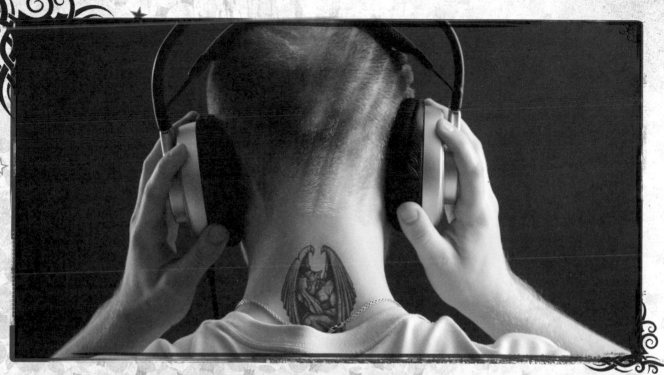

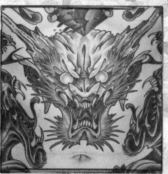

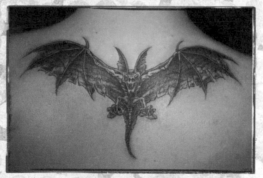

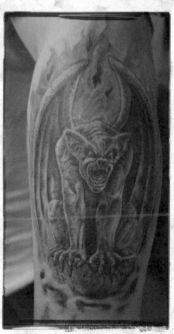

TROLLS & OTHER MYTHICAL CREATURES

Trolls are creatures from Scandinavian folklore—you may have come across them in fairy tales as well. As tattoos they do the same thing as gargoyles—chase away evil thanks to their intimidating appearance—but offer the wearer a different kind of image that may be more appealing to them. As far from trolls as you can get, unicorns and Pegasus are mythical horses symbolizing purity, strength, nobility, magic, and (in the case of winged Pegasus) a free spirit.

Foo Dogs

They're similar to dogs, but these amazing-looking mythical creatures are actually lions, which is why they're sometimes known as Lion Dogs or Lions of Buddha. They were created by Chinese artists over 2000 years ago who had heard of lions but never seen them (they're not native to China), so it's easy to see why they could look like dogs instead, which the artists would have been very familiar with.

Foo Dogs originally guarded Buddhist temples, and then Emporers' palaces, and protected them from evil spirits. In modern times they've been reincarnated (very Buddhist!) as Dogs of Happiness, guarding people's homes. In tattoos they combine the look of dogs and lions, and symbolize strength, authority, and pride. Foo Dogs protect guys who wear them, keeping them safe, just as their ancestors did for temples in ancient China. (And they never need walkies.)

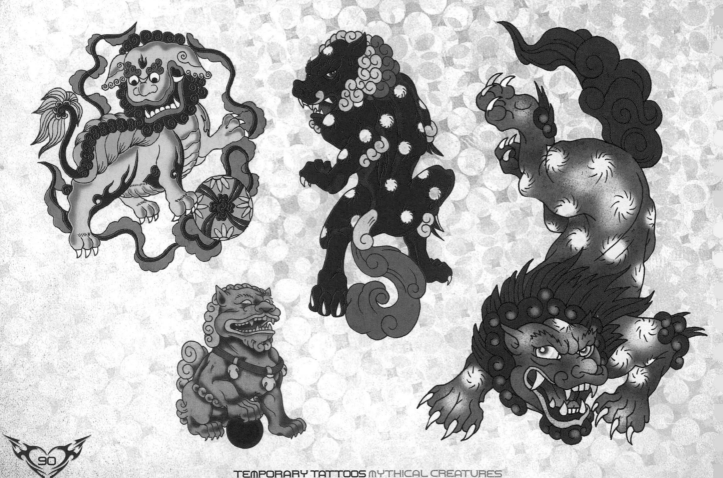

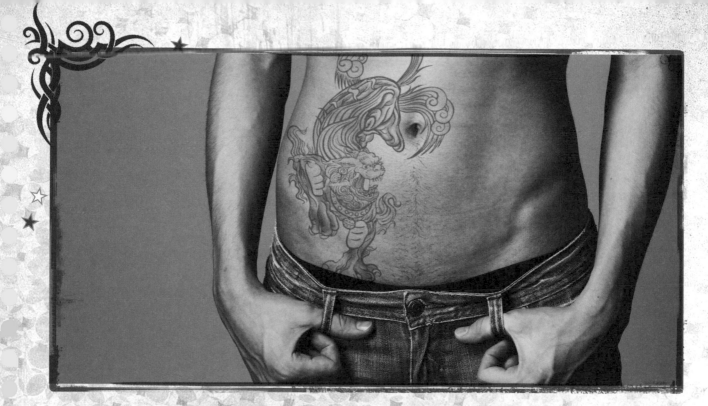

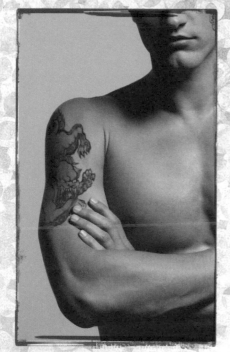

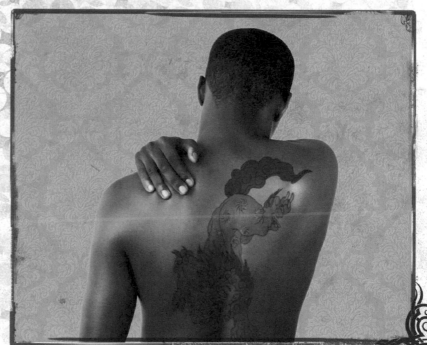

Vampires

Vampires come loaded with so much symbolism it's hard to know where to start. They can be representative of Goth culture or a sign that someone is into a particular music scene or lifestyle, for example, so guys can choose them for that reason alone.

However, a vampire is also a terrifying supernatural being whose very presence screams death, blood, and danger, and might be worn to look scary or to symbolize evil. In literature they could also stand for a fear of the unknown or of sexual freedom, making them a controversial image.

Vampires are blood-sucking creatures, so they can represent a feeling that something in your life is bleeding you dry; on the other hand, they can also stand for a thirst—for life, success, happiness, anything at all. Guys don't have to pick vampires as a negative, dark symbol, in other words.

The vampire is an image that just keeps changing and updating. Modern vampires have become cool and sensitive, attractive to girls, and very different to the ancient myths. Guys might want them as tattoos because they're strong, sexy, and immortal: death has never looked so good.

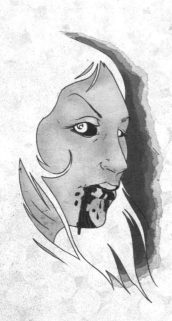

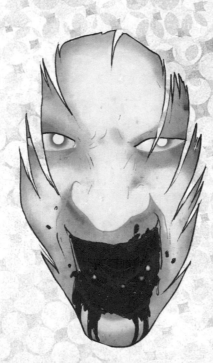

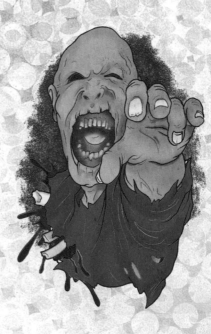

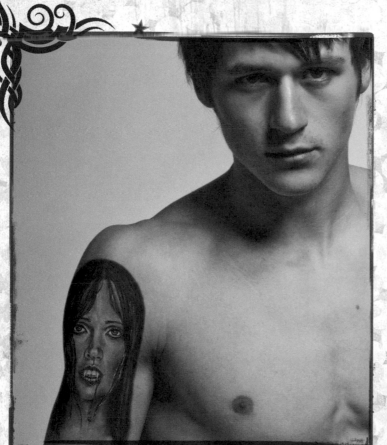

ZOMBIES

Zombies are linked with black magic in some cultures, but more recently they've become popular in movies and graphic novels, along with vampires. Zombies as tattoos can be disgusting and gory, slobbering for brains while chunks of their flesh hang loose—they're images that can be horrifying or funny, and guys like them for both reasons. That's not all though: on another level, zombie tattoos can represent the inevitable decay of the flesh, and an awareness of death; their mindless shuffling can even stand for the loss of individual identity in an increasingly faceless society ruled by CCTV, fast food, and mall culture. Not so brainless after all.

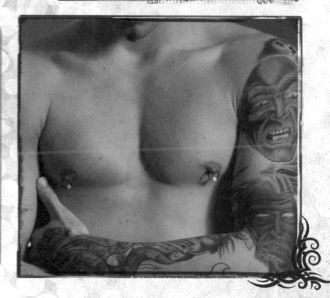

INDEX

94

CREDITS

Quintet wishes to thank Raven Sijohn at www.aaanativeart.com, Dominic Brown, and Phil Gibbs for their help with photos. All images other than those credited below are the copyright of Quintet Publishing Limited. While every effort has been made to credit contributors, Quintet Publishing would like to apologize should there have been any omissions or errors—and would be pleased to make the appropriate correction for future editions of the book.

T = top, B = bottom, C = center, L = left, R = right

aaanatiearts.com: 19 B © Raven Sijohn

Alamy: 13 BR © Ross Aitken/Alamy

Corbis: 11 TR © Alison Wright/CORBIS; 12 BR © Vincent Kessler/Corbis; 19 TR © Markus Cuff/CORBIS; 47 T © Mathew Scott/Corbis; 49 BR © Mathew Scott/Corbis

Fotolia: 9 LC © Sergei Tankov; 27 RC © Marco Rosarelli; 29 TL © Zurich; 29 TR © Miguel Cavazos; 55 TL © FXTW; 57 L © Valua Vitaly; 61 C © Chris Johnson; 61 R © Cora Reed; 67 L © Charlesknox; 75 TR © carcala; 81 BR © Gina Santa Maria; 83 L © martin1985; 83 C © R.-Andreas Klein; 89 C © Haramis Kalfar

Getty Images: 57 RC © Robert Van Der Hilst/Getty Images; 65 RC © 4 Eyes Photography/Getty Images; 69 L © DK Stock/Robert Glenn/Getty Images; 81 L © Photodisc/Getty Images

Independent: 21 TR, 25 L, 25 BR, 31 TC, 33 L, 37 TR © Dominic Brown; 63 BR; 67 TR; 89 BR © Stotker Tattoos

iStock: 9 BL; 12 TL © Todd Keith; 15 TR © Scott Griessel; 17 CL © Oscar Calero; 17 C; 17 BR © Robert Simon; 21 L © Les Byerley; 21 RC © Les Byerley; 21 BR © Les Byerley; 23 BL; 23 R © Emilie Duchesne; 27 TR © Josef Philipp; 27 BR © Darryl Allen; 29 CL © Felix Alim; 31 TL; 35 T © Marilyn Nieves; 35 BL © Robert Lerich; 41 T © Claudio Belli; 41 L © Les Byerley; 47 L © Ryan Klos; 47 R © Kevin Russ; 49 LC © Joe Augustine; 51 BR © Kevin Russ; 53 C © Karina Tischlinger; 55 TR © Francisco Romero; 59 T © Alain Nguyen; 61 L © Koch Valerie; 63 TR © Melanie James; 63 RC © Jane Norton; 65 L © Philip Beasley; 67 BR © Dave Everitt; 71 C © Les Byerley; 75 BR © Andrejs Pidjass; 77 BR © Carl Durocher; 79 TC © Elena Korenbaum; 83 BR © Keon Kim; 85 TL; 85 TC © Miroslav Georgijevic; 85 B © Francisco Romero; 87 BR © Olga Guzhevnikova; 89 L; 93 BR © Les Byerley

Shutterstock: 2 C, 3 C, 4 CL, 4 CR, 5 L, 5 C © BooHoo; 4 TL © bomg; 4 TR © John Lock; 4 BC © Morphart; 5 TL © kokitom; 5 BL © John Lock; 5 TR © Christos Georghiou; 5 BR © Ferin; 8 TR © Christos Georghiou; 9 TL © Tatiana Morozova; 9 LC © Scott Kapich; 10 BL © ChipPix; 11 LC © Charles Knox; 11 BL © Ronald Sumners; 11 BR © Polina Lobanova; 12 RC © ES James; 13 TL © iofoto; 13 TR © John Lock; 13 RC © Jon Le-Bon; 14 BR © Audrey Burmakin; 15 L © Monica Butnaru; 15 RC © Moremi; 15 BR © Moremi; 16 CL; 17 T © Heinz Waha; 18 BL, BR © Andrey Aurmakin; 19 TL © @erics; 19 TC © Dmitrijs Dmitrijevs; 23 TL © Andrey Arkusha; 23 LC © Iia Dukhnovska; 25 T © dundanim; 25 C; 27 L © Apollofoto; 26 BR © Sibear; 29 BR © Elena Ray; 31 TR © Mikael Damkier; 31 C © iofoto; 33 TR © Crystal Kirk; 31 RC © iofoto; 31 BR © Mtomicic; 35 BR © Matthew Stansfield; 37 TL © Sam DCruz; 37 C © Diedie; 37 BR © Sergei Bachlakov; 39 TL © Leslie Murray; 39 TR © Shae Cardenas; 39 RC © Dmitri Mikitenko; 39 BR © dundanim; 41 C © Vladimir Wrangel; 41 R © Diego Cervo; 43 TL; 43 TC © Elena Yakusheva; 43 TR © Dmitri Mikitenko; 43 B © konstantynov; 45 L © Dmitri Mikitenko; 45 TR © Ghaint; 45 RC © Miroslav Tolimir; 45 BR © ejwhite; 49 TL Danylchenko Iaroslav; 49 TR © Kiselev Andrey Valerevich; 51 L © Bairachnyi Dmitry; 51 TL © MaxFX; 51 RC © George Dolgikh; 53 T © Karin Hildebrand Lau; 53 L © tonobalaguerf; 53 BR © Losevsky Pavel; 54 BL © H Cooper; 55 TC © iofoto; 55 C © Kiselev Andrey Valerevich; 56 C © John Lock; 57 TR © Angela Hawkey; 57 BR © zimmytws; 59 BL © Jaimie Duplass; 59 BC © cjpdesigns; 59 BL © iofoto; 60 BL © M@x; 60 R © H Cooper; 61 T © Chris Howey; 63 L © Dean Mitchell; 65 TR © crystalfoto; 65 BR; 67 RC © Roxana Gonzalez; 69 TR © rj lerich; 69 CR © CURAphotography; 69 BR © Ghaint; 70 BR © Morphart; 71 T © Roxana Gonzalez; 71 L © AYAKOVLEVdotCOM; 71 R © Ghaint; 73 TL © iofoto; 73 TR © Condor 36; 73 C © iofoto; 73 BR © Sean Nel; 74 R © Morphart; 75 L © Aiti; 77 T © Poprugin Aleksey; 77 BL © Roxana Gonzalez; 77 BC © Paul Prescott; 79 TL © Dmitri Mihhailov; 79 TR © photobank.ch; 79 C © Istvan Csak; 81 TR © Gavel of Sky; 81 CR © Huang Uuetao; 83 T © Mircea BEZERGHEANU; 85 TR © Media Bakery13; 87 TL © Hugo Mass; 87 TR © Tereshchenko Dmitry; 89 T; 91 T © Raisa Kanareva; 91 BL © AYAKOVLEVdotCOM; 91 BR © Sean Prior; 93 TL © Gabi Moisa; 93 TR © Stepanov

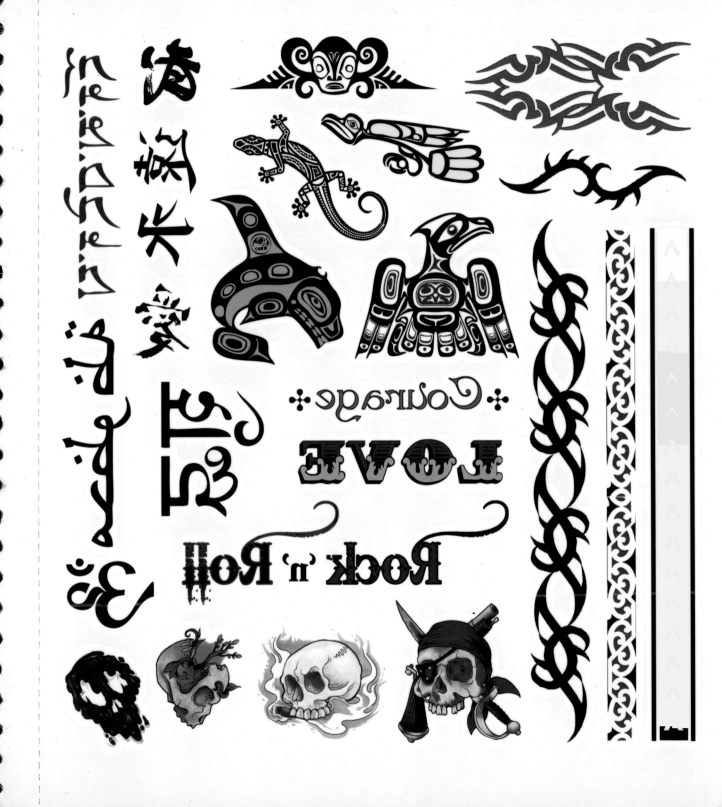

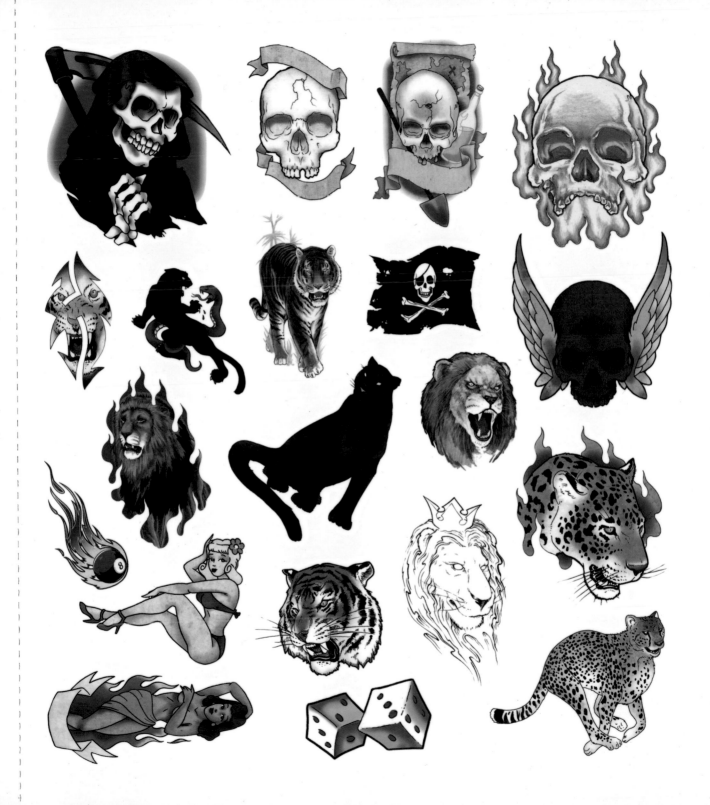

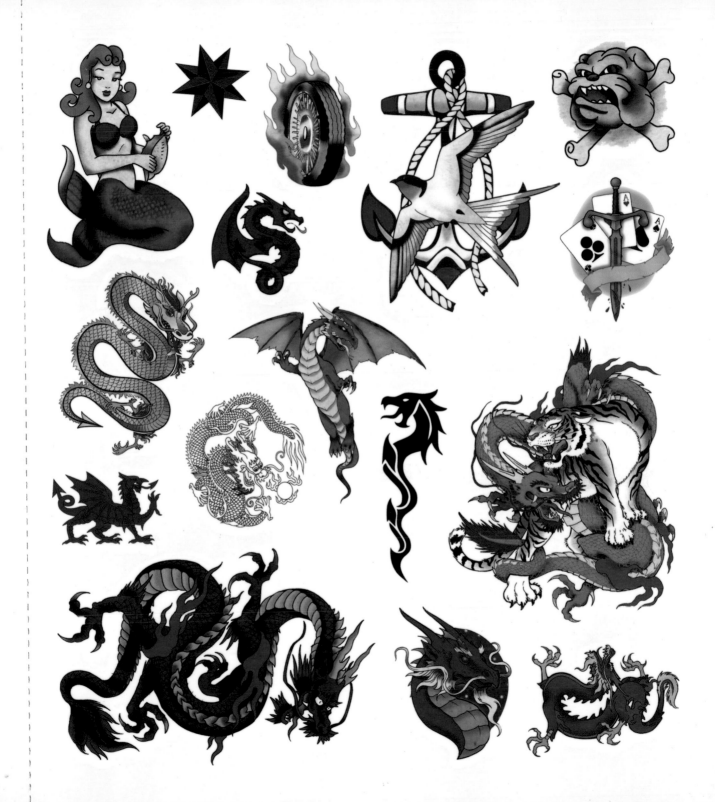

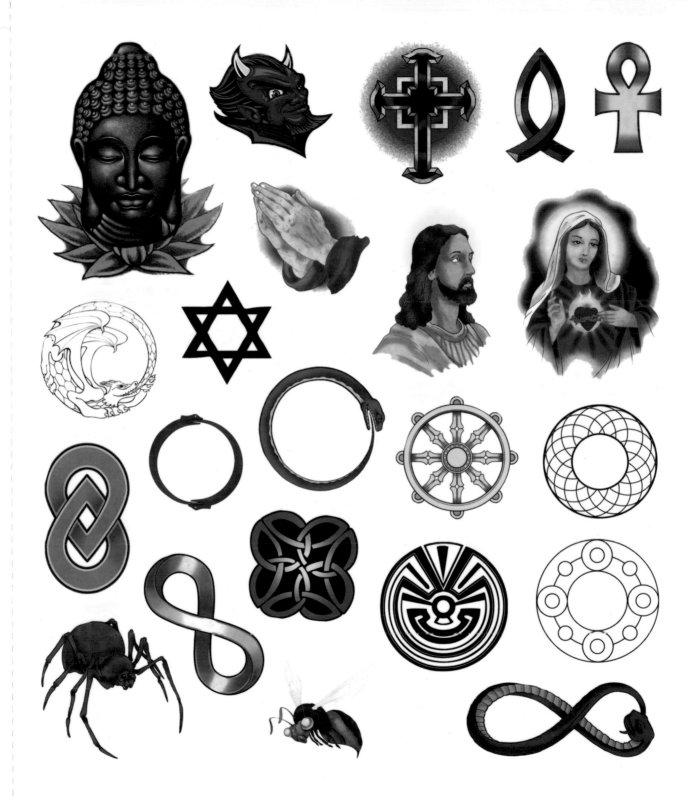